Crop Art

Crop Art

Harry N. Abrams, Inc., Publishers

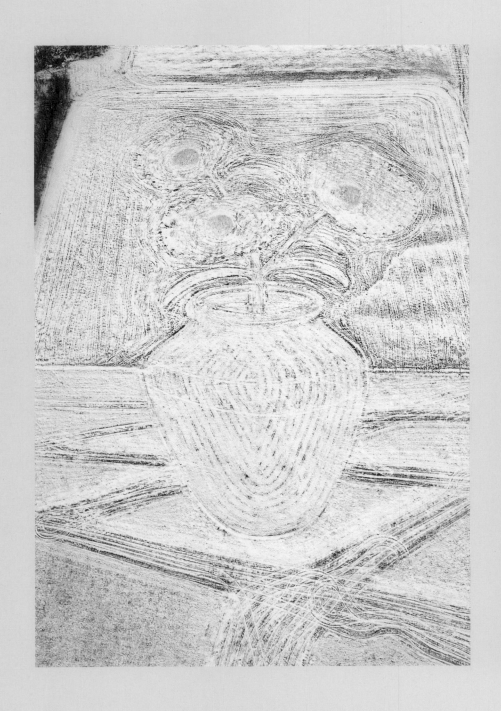

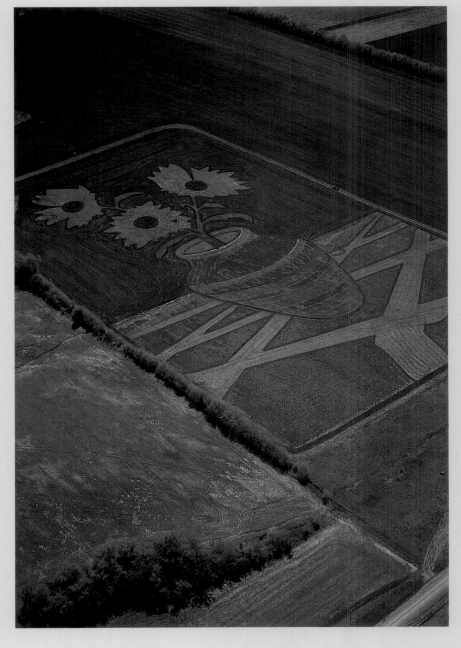

and Other Earthworks

By Stan Herd

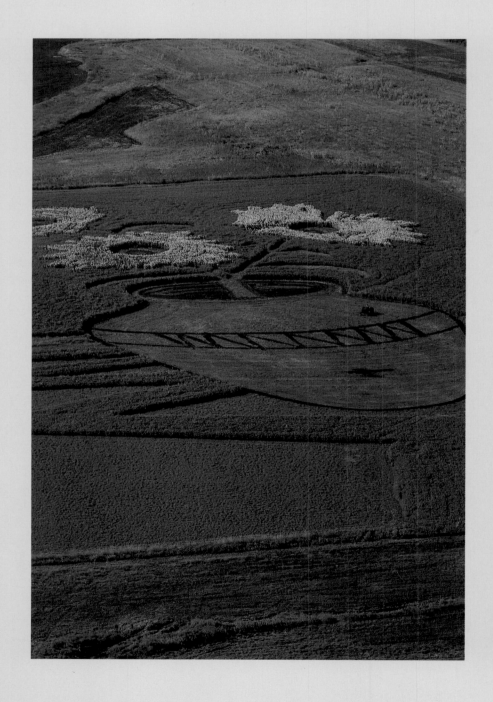

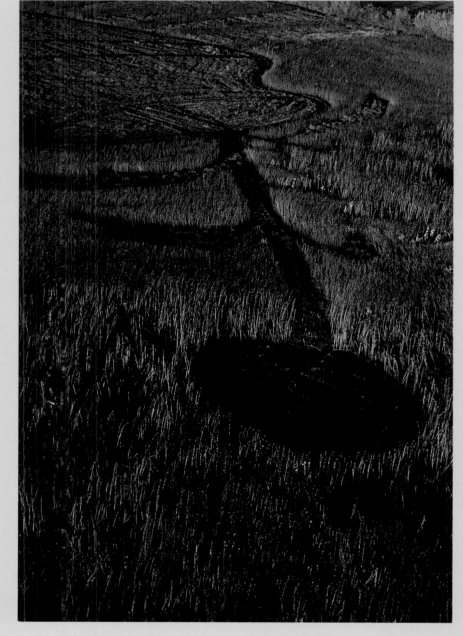

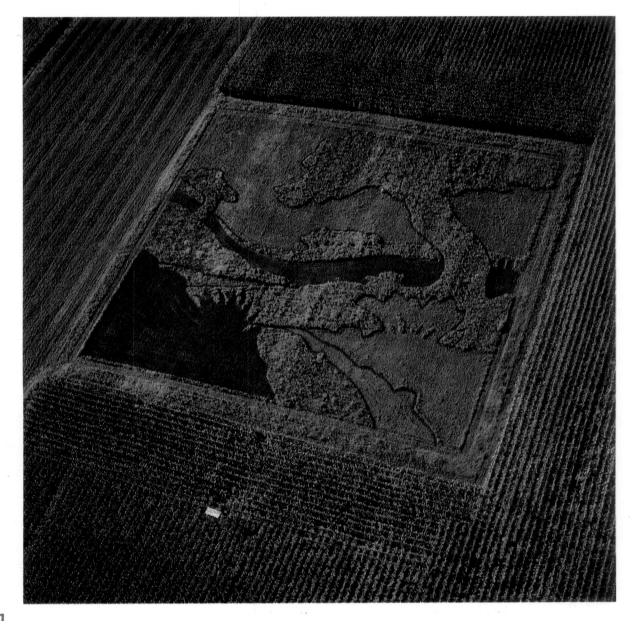

Page 1: In an attempt to avoid the midday heat, Stan Herd works at twilight on his *Will Rogers* earthwork.

Previous pages: *Sunflower Still Life* (from left to right) blanketed by a winter snow: just prior to planting in late spring; in full bloom in late summer; and as the flowers shed their golden petals in the fall.

Above: *Countryside* (1993), near Lawrence, Kansas, is a one-acre study for a field image planned for New York City.

Opposite, top to bottom: The artist mows portions of *The Harvest* (1987–88) to give the effect of shadow; using subtractive methods of plowing and mowing, Stan Herd begins to give his twenty-four-acre portrait of Saginaw Grant shape; on the campus of Haskell Indian Nations University, Herd's four-acre medicine wheel design marks the four directions and the winter and summer solstices.

Editor: Beverly Fazio Herter
Designer: Darilyn Lowe Carnes

Library of Congress Calaloging-in-Publication Data
Herd, Stanley J.
 Crop art and other earthworks / Stanley J. Herd.
 p. cm.
 ISBN 0–8109–2575–3
 1. Herd, Stanley J. 2. Earthworks (Art)—United States.
I. Title.
N6537.H3897A4 1994
709'.2—dc20 93–26839

Published in 1994 by Harry N. Abrams, Incorporated, New York
A Times Mirror Company

Printed and bound in Japan

Contents

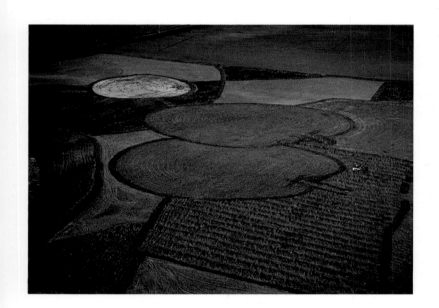

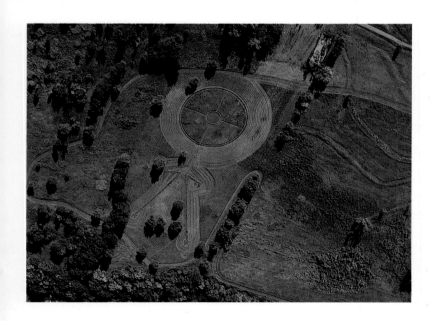

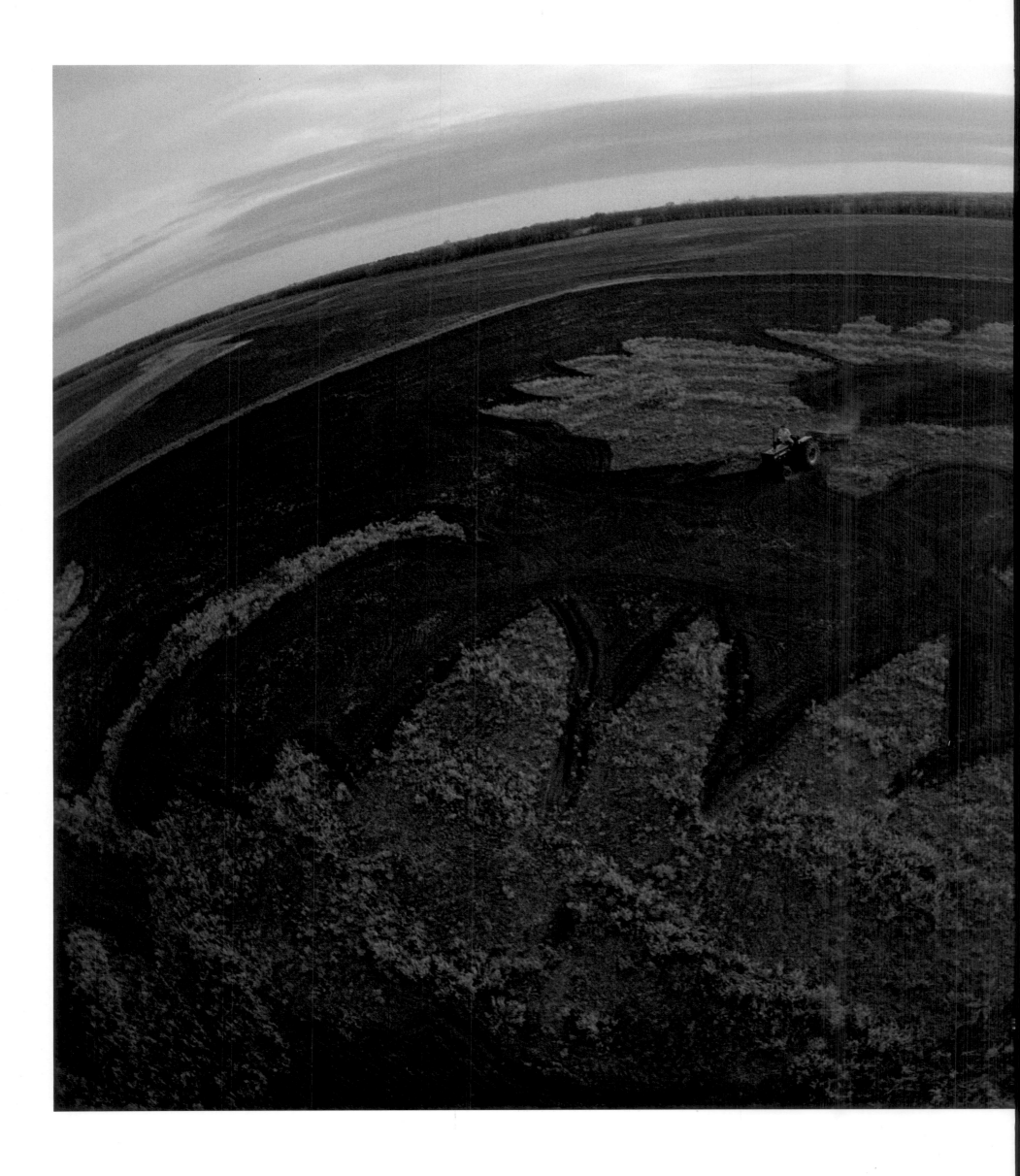

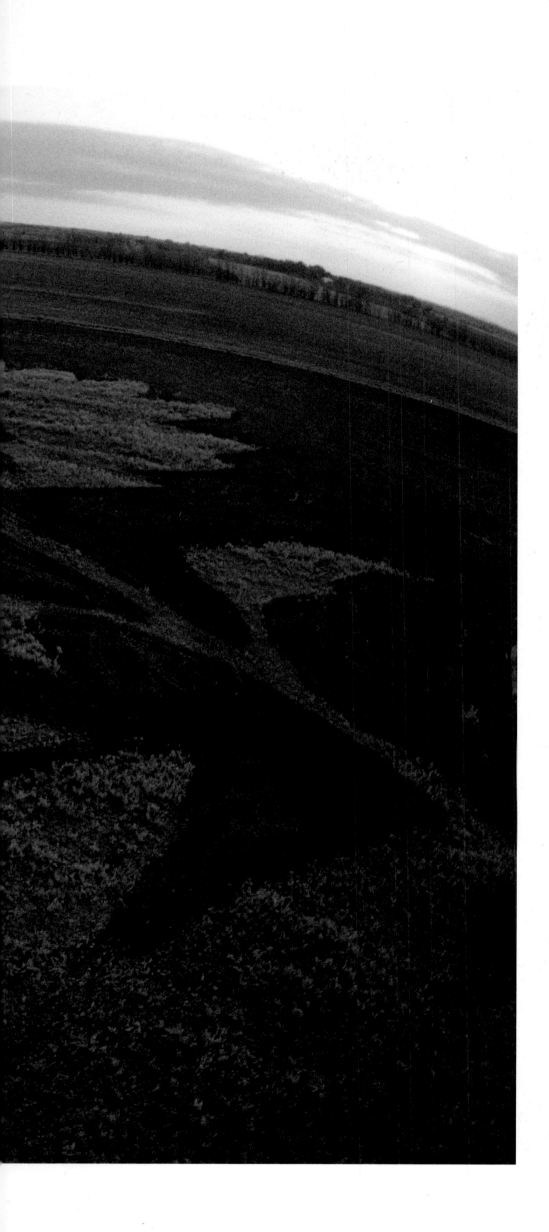

Introduction

A small, three-foot plow is used to outline
the design of *Sunflower Still Life* in spring of
1986.

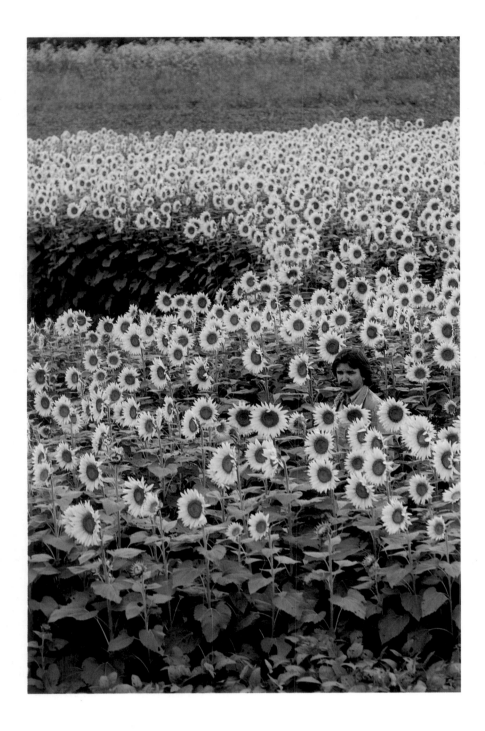

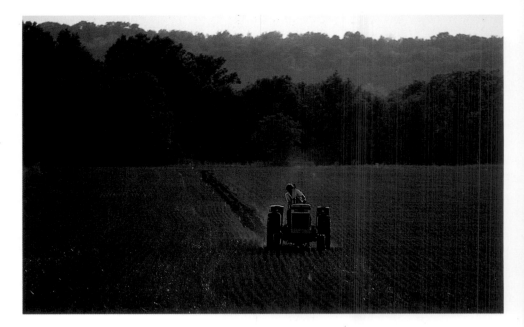

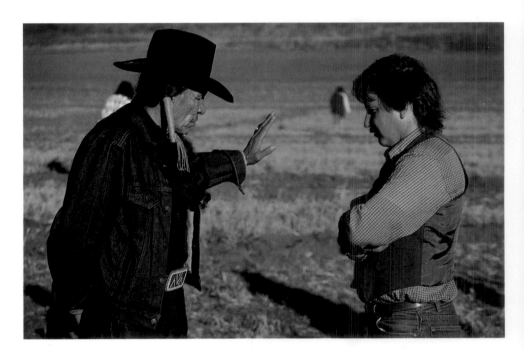

Above: The artist standing in a field of domestic sunflowers, part of his *Sunflower Still Life* image.

Right, above: Etching the serpentine outline of the *Saginaw Grant* image with a two-bottom plow in summer 1988.

Right, below: Saginaw Grant and Stan Herd.

INDEPENDENCE AND INTERDEPENDENCE

On many levels, from intellectual to spiritual, my life seems to have been a search for a middle ground between the ideas and ideals separating the country from the city. At the heart of this is the coastal perception that little of importance happens in the vast center of the country. Those who inhabit rural America are perceived as somewhat inferior and certainly less informed than those who reside in a metropolis. Country activities are merely support for truly important human endeavor taking place in the city.

Thousands of young people, the so-called boomer generation, flocked to the cities in the sixties and early seventies, to escape the boredom and the conventionality of rural America. Drawn by the excitement and social opportunity, we turned our backs on the slow pace of the farm and the conservative lifestyle of the small town. Farming lost much of its appeal, perhaps because of inordinately long hours and low pay. In the seventies and eighties agricultural land prices dropped to almost half their value in some areas while property values in many cities doubled.

Now twenty years later, thousands of Americans, some two and three generations off the farm, are beginning to return to the

country, searching for their agrarian roots and a simpler lifestyle. Stores and farmer's markets showcasing organically grown produce are sprouting up in every large city, and there appears to be a renewed respect for the lifestyle of people who farm, garden, and ranch.

In Thomas Jefferson's vision, the strength of this nation depended on a sturdy, independent yeoman: a viable community of property owners, with a strong sense of civic responsibility. Jefferson's ideal of a land-owning commoner gave way, in this land-rich country, to the "landed gentry." The percentage of people involved in the activity of agriculture, nationally, has diminished from around 70 percent in the late 1800s to approximately 2 percent of the population in 1990. Agriculture is now giant "agribusiness," utilizing highly technical and expensive machinery and heavily dependent on inputs from fossil fuels and chemical fertilizers, herbicides, and pesticides. The independent man working the small farm to provide for his family and immediate community has all but disappeared. Many of these once fiercely independent producers have donned the corporate uniform of agribusiness.

My earliest perceptions of artists both past and present are images of independent and uncompromised individuals fighting against conformity and authoritarianism. The independent man who worked the land, fished the sea, or quarried stone has also been a subject for artists at least since the time of Brueghel, and appears in the works of Constable, Millet, Breton, Courbet, and Van Gogh, among others. Many artists seemed to idealize and revere the common laborer or worker, perhaps as a symbol of original man, or of man free and unfettered. An idealized heroic common man, essentially unbridled from the power and influence of wealth, and remote from the political structure of the nation-state, seemed to be embodied in both the gentleman farmer and the artist and to be connected in spirit to the aboriginal free man in North America—the American Indian.

Today I sense that the struggle of the individual to maintain a separate and independent identity in the modern corporate era is ever more of a challenge. In America and elsewhere, farmers have yielded much independence to government programs. Their fortunes are now tied to political manipulations of international markets. Artists have fared little better. They appear to be increasingly subservient to the dictates of media and an art world power structure, while the American Indian was long ago overwhelmed by a conqueror's concept of Manifest Destiny.

Only recently have we seen signs of a fundamental shift in the public's perception, which has moved toward a more responsible stewardship of the earth's resources, along with a renewed interest in the cultural diversity of remaining tribal people whose ancient belief held at its core a strong land ethic.

COMING OF AGE IN THE SIXTIES

A number of national news stories in the late sixties addressed problems of contemporary Indian people struggling to exist on scattered reservations. Like many of my generation, I was maturing as somewhat a counter-culture antiestablishmentarian. Via television, along with many of my peers, I had witnessed the assassinations of the Kennedy brothers, saw hateful abuses of minorities, and watched the Rev. Martin Luther King, Jr., and his followers begin to assert themselves. My generation tried to comprehend efforts by our national leaders to involve us in a war in a place essentially unknown to us. Armed with a perception that most of our parents' generation cared too much about social status and money, many of the nation's young people were taking to the streets in cities and on college campuses to protest perceived injustices and waste in a world we wanted to change.

In some ways we failed to understand fully the history of the older generation. Most of us had little appreciation for the twin epochal events that had transformed American culture and helped define our parents' values. As children coming out of the poverty of the Great Depression into a global war defending against tyranny and fascism, this generation felt strongly about gathering deferred material rewards, which after the war became available in an abundance previously unimagined.

Coming of age in more comfortable circumstances, my generation was afforded the luxury of focusing on remaining social injustices. During this era of an ideological separation of the generations, the fledgling "American Indian Movement" was finding common ground with non-Indian sons and daughters who were turning away from the nuclear family and a belief in the American Dream. Many of the issues of the sixties, such as concern about overt consumerism and a perceived exploitation of nature and people, spoke to values equally shared by long-haired whites and Indian protestors. We seemed to be kindred spirits. Many non-Indians adopted the spiritual symbols of Native people with little or no understanding of the complexities of Indians' religion or their equally complex contemporary problems. Some Indian leaders accepted the white collaborationists. Others did not. It is my understanding that there remains a philosophical division along those lines.

That the sixties movement was in part naive is a given. Some participants recognized its weaknesses at the time. Sometimes destructive, the movement often seemed confused and ambiguous in that it lacked well-defined goals and direction. Many young people jumped into the fray for the party. Nevertheless, the movement was important in American history; its ramifications are still being felt globally. I believe it improved civil rights here and abroad, created more environmental awareness, engendered a more careful corporate stewardship of natural resources, and led most Americans to an increased sensitivity toward minority viewpoints and to a respect for people of races and religions not their own

THE FARM WORLD

As an artist with a special love for the land, I remember summers of my childhood riding the tractor on windswept fields of the High Plains. With my imagination to keep me company, I came to view the land through stories and observations of my parents and grandparents. I watched as they handled the earth, running it through their hands while testing for moisture and signs of life. They often spoke of it as if it were a

living thing, and we were taught to think of the earth as life-giving or bountiful. A man who farmed a quarter-section of good fertile ground was "blessed." Conversations about a particular piece of ground, its assets and weaknesses, and how to deal with that in the planting of crops, were fundamental to my childhood view of nature.

As we each reached the age of eleven or twelve my sister, four brothers, and I took our turn behind the steering wheel of the tractor to receive instructions from our father on how to operate that vital piece of farm machinery. For us it became a rite of passage.

As a small boy, I remember on a particular spring day standing at the edge of a patch of ground just south of our farmhouse with my older brother Steve. We were watching my father on the old Moline tractor as he schooled my sister, Cheryl, eldest of my siblings, on the fine points of lifting the plow out of the ground to make a turn. The tutoring effort fell apart after a few hours, and to my knowledge it was my sister's last fling with farming. I watched as a red-tailed hawk repeatedly swept down to snatch field mice scurrying from the onset of the tractor. A coyote slipped along the fence line. I remember being exhilarated by the rich, pungent smell of newly plowed earth, and thinking that people in the city are often taught that soil is dirty . . . something to scrub away.

Bluff Creek ran through our back pasture and rolled with an occasional fury in years when torrential rains would run off baked fields beaten hard by the plow and by ever-heavier tractors. Hailstorms and tornados were a fundamental part of life in southwestern Kansas. And sometimes they worked to destroy life. One night my father came in, face ghostly white and soaked with rain, to whisper to my mother that it was gone, all of it! We all sat on the couch and cried. The wheat crop had been stripped to the ground by hail the size of tennis balls. A year's work gone. Two days before harvest.

STUDENT YEARS

As my interest developed in the larger world and as I was striving toward a means of artistic expression, the land and man's relation to it spiritually, intellectually, and historically were central to my thinking. It is not an accident that many of my works, from my first sketches as a child to the large earthworks of the eighties and nineties, are directly related to American Indians whose relationship to the land was at the heart of their religion and their culture. In addition to depicting people, my earliest drawings also included historical and contemporary activities concerning life in rural America. Always they were depicted on the land; on the high plains of southwest Kansas; on gently rolling hills of sagebrush and pasture broken by fields of wheat and alfalfa crossed by countless country roads leading nowhere and everywhere. I longed to head down those roads and find out what lay beyond the horizon. An urge to discover was never far from the surface.

By the early seventies I began to ponder what contribution an artist on the plains could make to the greater world of art. I think I knew instinctively that any such contribution must issue

from insights already gained, and concluded that my own unique experience was to have observed, late in the process, a vanishing way of life—the living out of lives on so-called family farms. When, in 1974, I returned to my hometown after being immersed in an urban culture for five years, it was impressed on me that America was being rapidly transformed from an agrarian culture, which for two hundred years had held at its center independent men and women working with and living on the land.

My parents, who had shared that rural experience, both strongly supported me in my wish to pursue art. They had invested scarce dollars for a "study-at-home" art school program while I was in junior high. In retrospect that had had an important impact on my developing sense of myself as an artist. With only a minimum of formal art training, my portfolio (and probably my tuition money) was convincing enough for me to be accepted by the Kansas City Art Institute. But when I visited the big city and the midtown location of the campus, it was in such stark contrast to my small town orientation that I reconsidered my course, leading to a compromise. In 1969, I accepted an art scholarship at the state university in Wichita, still far away but closer to my hometown.

My ability to understand the nuances of "modern art" and "abstraction" came slowly. I viewed them with some suspicion. Even as I gained a grasp on principles of color and perspective, and as I learned to deal with form, shadow, and the human figure during my studies at the university, I still found it a little hard to fathom the significance of Jackson Pollock and the Abstract Expressionists. But by the time of my first field image in 1981, I had gained a clearer understanding of the philosophical and aesthetic territory seized by Pollock and the midcentury American art movements.

In the midseventies I came to a clearer understanding of the struggle that had been going on in the art world in recent decades. The essence of that struggle seemed to be that individual expression was seeking primacy over a necessity to conform to expectations, expectations for an artform dictated by what is acceptable either to the masses or to a particular ruling elite. By the seventies, nonobjective painting had become acceptable to the masses and representational art was frowned on by those who mattered. I believed, at the time, that I was acting boldly to attempt a representational portrait in an atmosphere where very little shocked the public anymore. Everyone seemed to be in on the modernist game. From the fashion industry to discount stores, images of the avant-garde permeated our culture. Pop/Op art was becoming popular as the style of the day, and art students from Poughkeepsie to Wichita were vigorously attacking canvas with what I later came to regard as "biomorphic expressions of the nebulous continuum," words which paraphrase and embellish a classroom description by University of Kansas art history professor Dr. Timothy Mitchell.

While struggling with those realities, I was given an opportunity to study the situation firsthand. As is perhaps the case with many students from the midwest, my first trip to New York was enlightening and overwhelming. Traveling as a chaperone with a friend and his college art class in 1979, I had blitzed the city for ten days, missing few major museums or galleries.

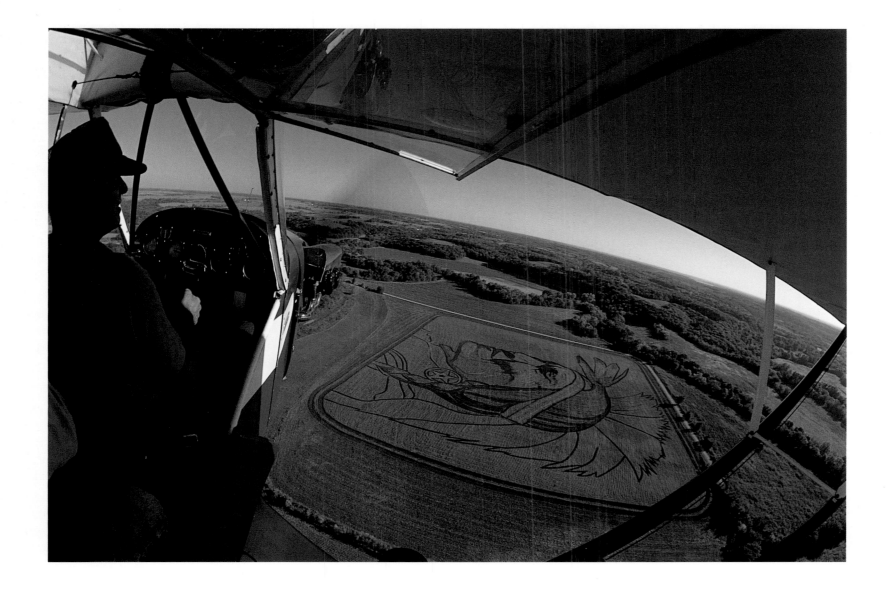

Aerial photographer Dan Dancer captures
the pilot overlooking an earthwork under
the wing of an old Stearman biplane.

After viewing minimalist works at the Museum of Modern Art, I
concluded that the modernist experiment, though grand and
important, had come to some conclusion. The decisive moment
for me came as I viewed Josef Albers's *Ascending Squares*. Stand-
ing before that image in 1979, I saw a logical evolution from the
Post-Impressionists to Albers, ending with a simple, uncluttered
square of color. To me, that square represented my open field
back in Kansas. I was free to go back and do anything I wanted.
In a way, it was a psychological release for me because I was
very aware of wanting to create art that was "of my time."

My observation that the modern experiment had ended
with the minimalists may have widely missed the mark, but at
least I had a point of departure. I returned home from the East
Coast with renewed determination to pursue my earlier vision of
an earthwork, a 160-acre portrait of a man who, one hundred
years earlier, had walked on the very earth of my childhood
home.

In studio work my interest in Impressionism, Surrealism,
and other aspects of early Modernism had continued to evolve as
I became a little better grounded in the basics of art history, espe-
cially American art history. Concurrent with that, I came to recog-
nize that popular "western" art was essentially romanticized and,
for the most part, a backward-looking anomaly in the art world.
Although I was painting western historical subject matter to finan-
cially sustain myself as the concept for a first field image grew, I
consciously attempted to disregard both contemporary modernist
and romantic western influences. In my mind, attempting a Native
American portrait as a first earthwork had little to do with the
past. It was an attempt to address the future.

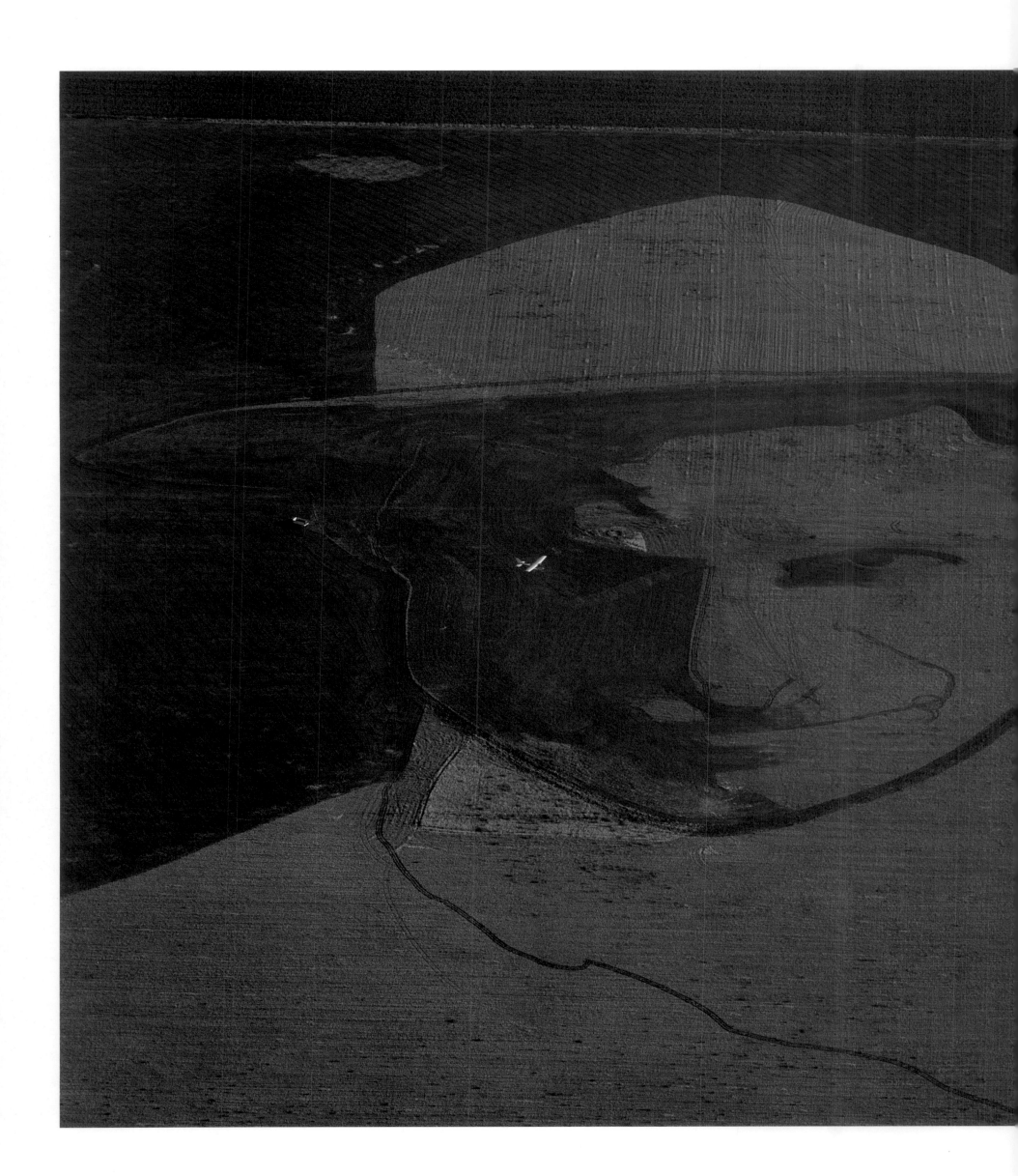

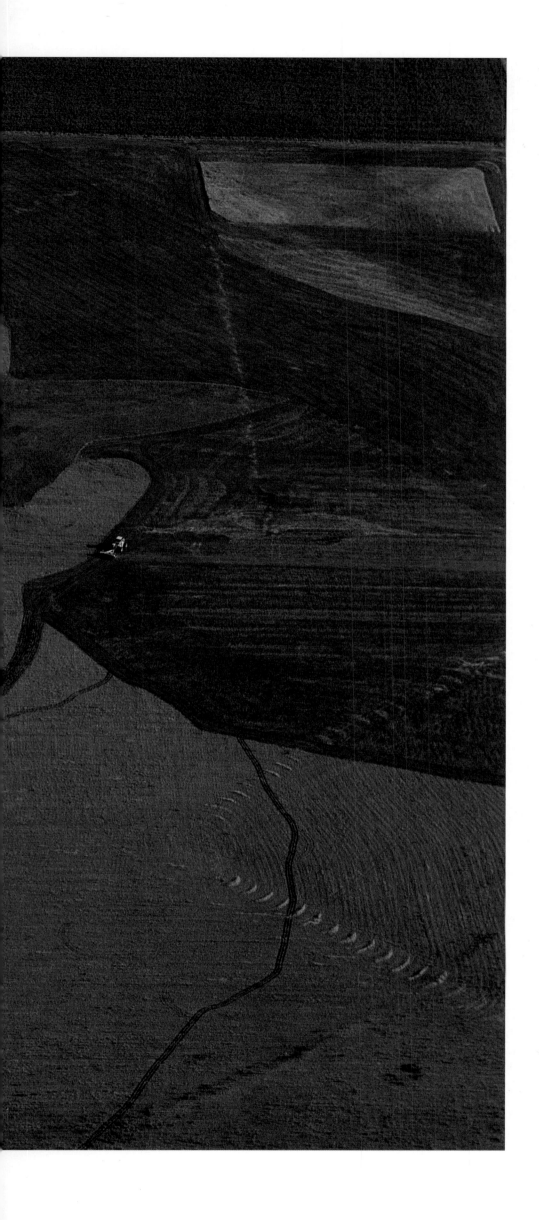

Early Works

The *Will Rogers* portrait became a lesson in forbearance. An intense summer drought mutes the image and curtails the efforts to plant grain crops for a more colorful portrait.

*F*randa Flyingman introduced herself as a descendent of Kiowa War Chief Satanta. We were meeting at a faculty assembly at Haskell Indian Nations University one warm summer day in 1992. She said she remembered well my earth-work portrait of her ancestor from 1981. In 1976, I had chosen Satanta as the subject for my first field image, although I had been only vaguely aware that Kiowa people were still living in the area of their historic homeland a few miles away in the neighboring state of Oklahoma.

Two counties on the southern border of Kansas were named after local Indian tribes, the Kiowa and the Comanche. Our family farmstead is in the latter. I learned early that Oklahoma was a Choctaw word meaning "red man" from their "okla humma." In that part of the world, on the Kansas/Oklahoma border, Indian lore had been a small but inevitable part of my childhood.

The meeting with Franda, an instructor at Haskell, brought to full circle an artistic and spiritual journey . . . back to the subject of my first true inspiration. In Indian lore the circle is a powerful symbol, and it has come to be that for me as well. I now see it as a metaphor for both my art and my life, and this book is a record of that journey.

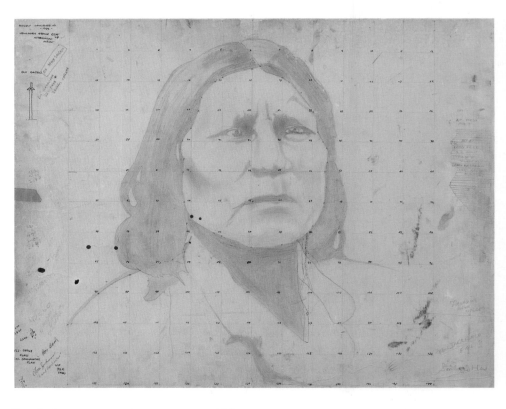

Two-inch squares, each representing 100-foot squares on the field, form the grid of the preliminary field drawing for *Satanta*, Herd's first earthwork. The field coordinates were marked with numbered flags.

SATANTA

*W*ith the advent of the airplane and the eventual prolif-eration of transcontinental flight, large numbers of people began to view the earth from above for the first time and bear witness to the permanent patchwork quilt design of civilization, etched by the railways, roads, industry, agri-culture, and urban sprawl. Concurrently we began to discover other designs and images, barely discernible from the ground, which had been created by people hundreds and sometimes thousands of years before.

My earliest memory of an aerial view of an earth design came from a television documentary about drawings discovered on the desert floors of South America, in the Nazca Desert of Peru. I was in my early teens. Some years after conceptualizing my own first earthwork, and when pursuing its implementation, I would begin to appreciate how extensive and far-reaching were the efforts of past civilizations to design on the face of the earth. Arti-sans and tribal people from ancient times manipulated the earth to make images, some of which were mounds used for burial or ceremonial purposes. Many of the designs are still not fully under-stood by modern archaeologists and anthropologists, and may continue to remain a mystery. But they all seem consistent with the idea that tribal people almost always place at the center of their spirituality and religion a deep-seated reverence for nature.

The same fascination with ancient and primitive design that had captured the imaginations of Picasso, Braque, and other of their contemporaries was, to me, an equally valid point of

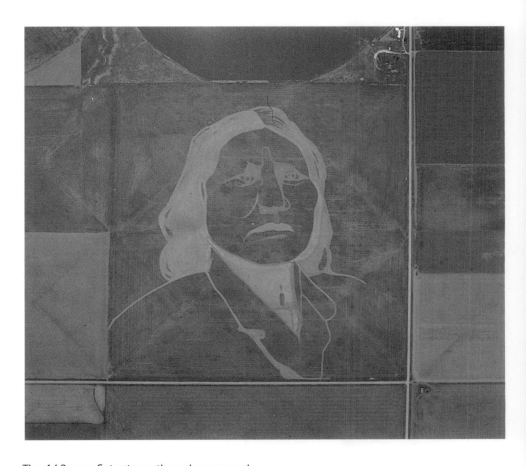

The 160-acre *Satanta* earthwork appeared as a negative of the preliminary drawing because of the onset of dark green volunteer wheat. Summer 1981.

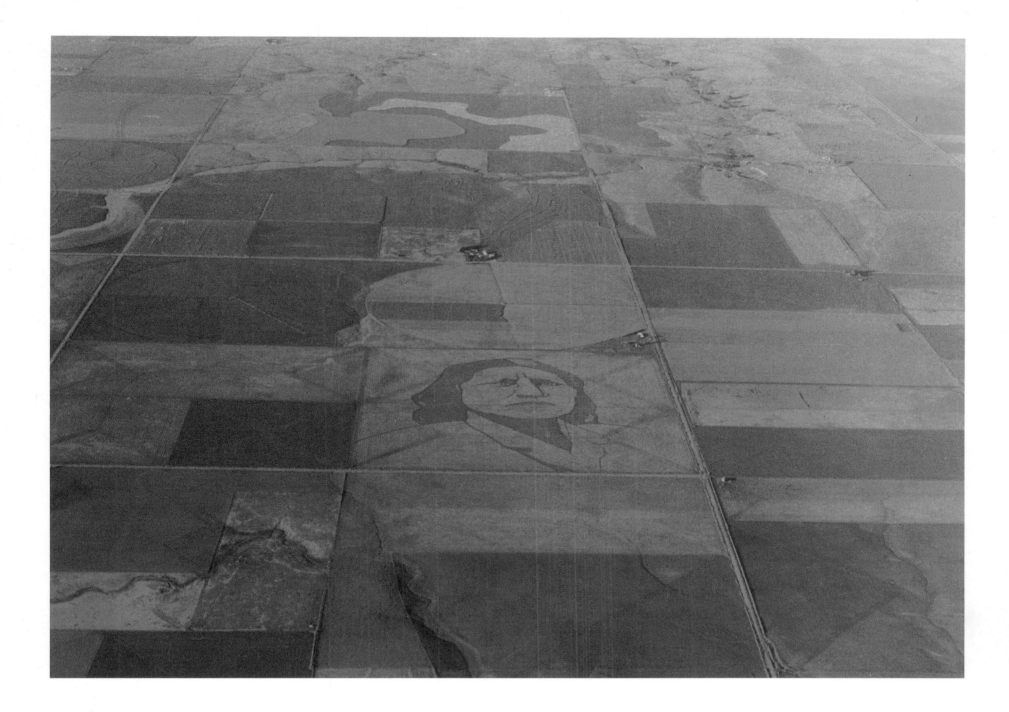

departure for an artist contemplating earthworks in the seventies after searching for a unique viewpoint that would issue from the Heartland.

One early afternoon in the fall of 1976, I rented a plane and hired a pilot to fly over downtown Dodge City, Kansas, where I had been making my home for two years. I intended to photograph from the air a Pop/Op art design that I had painted on the exterior of a building. On the return flight to the airport, I first considered an idea that captured my imagination and forever changed my life. Two miles from touching down we had passed over a single tractor sweeping diagonally across the expanse of a quarter-section of ground. The field had been "worked" earlier and following a rain had crusted over to a light tan color. The farmer's barely discernible movement was now marked by a rich dark line of freshly turned soil. On that day I resolved to attempt an image on the land, using tools and methods that generations of my family had employed for their livelihood.

My reasons for choosing Kiowa Chief Satanta as a subject for my first earthwork were many. Satanta had been an important participant in the historic Medicine Lodge Peace Treaty of 1867, which was signed in southwestern Kansas, fifty miles from my hometown. He had risen to power as a war chief in his thirties and became a symbol of Indian resistance to European encroach-

Chief Satanta's portrait lies on the flat, semiarid high plains of southwest Kansas, the region marking the far northern hunting grounds of the Kiowa people. The area is currently dependent almost entirely on agriculture.

ment. The northernmost territory of the Kiowa hunting range was in an area of the Arkansas River near present-day Dodge City. It is told that Satanta, on a raiding trip in the territory, lifted a number of cavalry horses from Fort Dodge under the noses of the guards, and tipped his hat (one previously awarded to him in a military ceremony) to the frustrated soldiers as he departed.

During the Medicine Lodge meeting, Henry M. Stanley (who later tracked down Dr. David Livingstone in Africa) was working at the time as a correspondent for the *Missouri Democrat*. After meeting Satanta, Stanley wrote of him: "He has won a great name for reckless daring all the way from Arkansas to the Rio Grande. His name is on every lip and his praises are sounded by the young damsels of his tribe as the greatest chief and warrior of the red men." Satanta spoke five languages fluently—four Indian tongues and Spanish. Reputedly, he spoke well and long. His eloquence inspired newsmen to dub him the "Orator of the Plains."

It would take five long years and numerous setbacks before I could finally walk onto a field with a transit and crew to lay out the grid for this first earthwork. Two of these years were marked by family disasters, consecutive wheat crop failures, both crops having been destroyed by hail. A downturn in agricultural prices and an upturn in farm foreclosures made adventurous art experimentation a hard sell. In that negative economic climate I had trouble finding anyone willing to participate in my proposed art project.

In 1977 or 1978, while still attempting to pursue implementation of the Satanta portrait, I viewed a documentary that gave me a new understanding of what lay before me. The film covered a four-year-long effort by the artist Christo and his wife, Jeanne Claude, to erect a temporary "running fence" over twenty-four miles of ranchland in California. The project had been completed the previous year. I realized then that my efforts, even my failed efforts, were part of the history of the project, but only if I persevered to the conclusion of the work. Christo stated in a 1979 interview that "the work of art is the dynamic stage of several months or years. The lifetime of the work is the work, and the physical object is at the end of the work, and of course that is the essence of that project."[1] I also identified strongly with the fact that Christo's success hinged on his ability to communicate his artistic vision to people outside the art world. Jeanne Claude remarked in the same interview that the key to their acceptance was their genuine interest in the people who were involved in the art endeavor. I also found that to be a key to success in my work, especially when talking to land owners.

Lester Rogers was an inventor, a dreamer, a farmer, and the mayor of Jetmore, Kansas, located fifteen miles north of Dodge City. His nephew, Tom Zachman, after hearing of my frustrations in securing land for an earthwork, arranged an introduction. Lester appeared skeptical about using his land as a canvas. He said he would have to think about it. Having used that same ploy most of my adult life to fend off salesmen of all stripes, I didn't have high hopes, but by now I appreciated any reply short of "git th' hell off my land." To my surprise, the next day Tom called to tell me Lester had thought it over and decided he liked the idea. After running the concept by Ron Bach, a young farmer leasing some of Lester's ground, we were off and running.

Without money, but with a newfound recognition of my ability to "sell" myself and my ideas, I approached an equipment dealer for the use of a tractor and began to trade artwork for the materials necessary to start the project. Although the original idea had centered on planting crops, which would effectively take the ground out of its natural rotation, I fell back to the idea of a less involved *subtractive* method of defining the image with implements which could scrape, sweep, and turn over the earth and vegetation for contrast and texture.

After creating an original pencil sketch from a popular photograph of Satanta, breaking the image down into sharply defined and graphic lines and areas, I laid down a grid consisting of one-inch squares. Each square on the field would measure one hundred feet by one hundred feet. The grid will be explained in greater detail later. My canvas was a 160-acre wheatfield that had been recently harvested of the grain, leaving the stubble or remnants of the wheat plant, about six to eight inches tall and a golden yellow color.

The defining moment came when I dropped the small disc (an implement pulled by the tractor) into the ground and proceeded in a wide arc, following the numbered flags like a road map, out into the field to outline the left shoulder of Satanta. For a week prior to this day I had worked with a small crew using a transit (a surveying tool), tape measures, and numbered flags to measure and mark the half-mile-square field in a giant grid in preparation for the tractor work. It took six hours to map my way onto and then off the field, leaving the essential outline of the image. At the end of the day, I headed back to the airport to fly over the rough outline and gauge results. It was an incredible feeling of accomplishment as we slowly approached the image at one thousand feet and I discovered the outline perfectly mimicked my original design.

Southwest Kansas is situated on what could be called a semi-arid high plains with a minimum of annual rainfall, making farming a precarious pursuit and *farming for art* even more of a gamble. My first direct experience creating with a partner as volatile and unpredictable as mother nature was a lesson in humility. After the initial outline was placed on the field the skies opened up in a rare display of activity for a Kansas midsummer, inundating the field for three weeks with sheets of rain. The golden wheat stubble, which was to highlight my first earth image, was quickly hidden by the onset of green "volunteer wheat" sprouting from seeds that fell to the ground at harvest one month earlier. The dark rich earth, which was to perform visually as shadow and line, dried out to a rather light tan and my image became more like a negative of what was intended.

After more than one hundred hours on the field, the first media representatives appeared, and I found myself attempting to communicate verbally that which had been only an artist's vision. Two months later when the television cameras and writers from the coasts had all departed, the ground was swept with an implement that severs the roots of the volunteer wheat, leaving the remaining yellow stubble on top, and for the first time, my flight over the image revealed the desired graphic image with appropriate dark shadow. I managed to capture that image with one or two good photographs before it faded into obscurity.

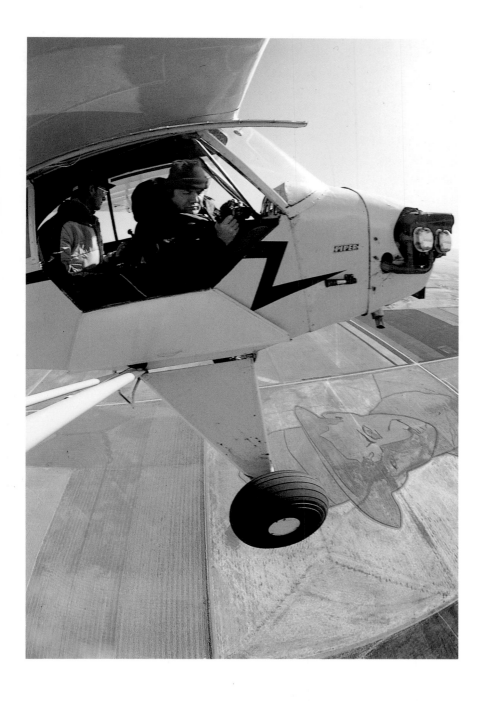

Left: Peter B. Kaplan adjusts his wing-mounted camera while hovering above the 160-acre portrait of Will Rogers, fall 1983.

Below: Will's portrait baked under a record-setting heatwave; for twenty-one consecutive days temperatures hovered at 100 degrees Fahrenheit.

WILL ROGERS

When Peter B. Kaplan arrived in Dodge City wearing his Mickey Mouse earring in 1983, the good ol' boys at the Cowtown Club were reluctant to embrace. Kaplan arrived with his suitcases full of cameras, a New York swagger, and a freelance assignment from *Geo* magazine to document my *Will Rogers* portrait inscribed and planted on 160 acres, four miles from the earlier *Satanta* field. The wheatfield portrait of the world-renowned humorist had been suffering through one of southwest Kansas's longest droughts in years. I worked hard to make it presentable.

Kaplan, the primary photographer for the Statue of Liberty renovation project, was known for his ability to leap tall buildings in a single bound after publication of his book *High on New York*, which depicts New York City from the tops of sky-

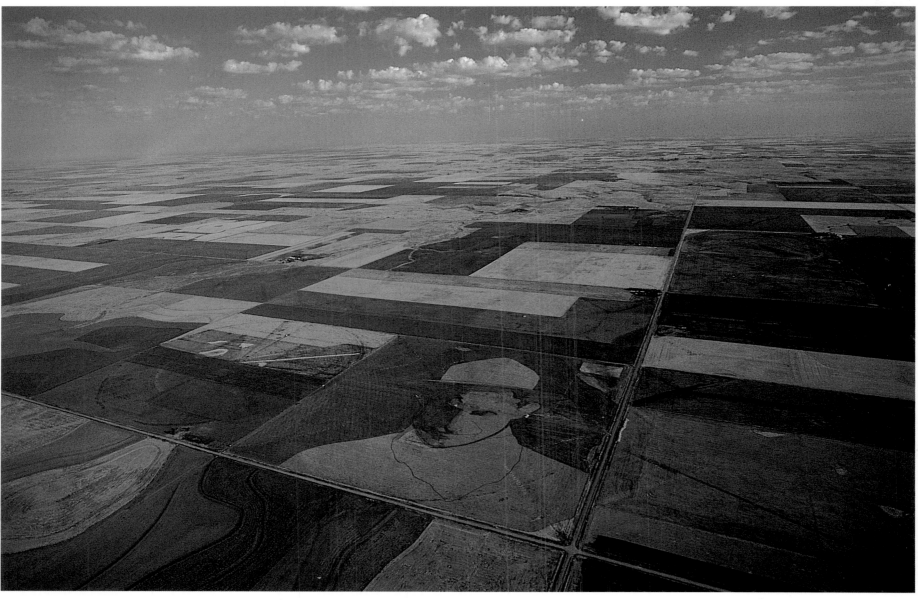

scrapers and bridges. For three days he orchestrated aerial formations over the *Will Rogers* field with a camera mounted on a wing tip, enabling him to show the scale of the image by capturing a second plane in his photographs. Additionally, he employed a one hundred–foot crane mounted on a truck to photograph the image from unique angles and perspectives.

This half mile—by—half mile portrait, my second attempt at an earthwork, was primarily motivated by a desire to incorporate crops into an image. Since conceptualizing the Satanta image seven years earlier, I had been mentally recording colors, textures and contrasts of grains, grasses, and produce of the region with an image in mind. Louie Byers, a landowner and agricultural entrepreneur, had dabbled in numerous new farming methods as a means of survival in the region known as the dry farm belt. Intrigued, he took up the challenge of helping me. After doing an initial layout and the first planting of maize (a feed grain), I was elated to see a large storm front building to the southwest. But it missed my newly planted portrait by two miles. That was as close as natural moisture came to the field for seventy days.

Three weeks into the effort, I convinced Louie Byers and his partners to help me lay irrigation pipe so I could water the strategically planted crops by hand. Following a month-long struggle we were "rewarded" with a paltry stand of maize that gave a *slight* rust hue to the shadowed side of the portrait. My disappointment was immense. Problems abounded. Tractors broke down. Pipes burst. Tires went flat. For twenty straight days the field cooked under 100-degree heat. I took each disaster personally, including a devastating call from Louie in late September telling me the portrait would have to be plowed under. That was a dark day indeed.

It seems the stunted crop we had planted for color had put him in noncompliance with government regulations he had earlier contracted to follow. As Louie had not viewed the work as a growing of crops to harvest, his contractual commitment had been overlooked, lost in his newfound enthusiasm for art. When the representative of the local ag office read about the project in a newspaper, the word came down that we had four days to clear the field. They reminded Louie he had voluntarily entered into a government program that specified no feed grain crops could be planted on that quarter-section of ground. In a move that perhaps would have confounded Will Rogers, a responsive congressman, Pat Robertson, intervened on our behalf. The field art piece was soon reclassified as a wildlife refuge. I learned then that bureaucracy sometimes does have a face behind the screen, and can have a heart as well.

At the end of this ordeal, I had come to a new appreciation of Christo's work and its significance. I had learned that the process *is* as important as the final visual manifestation of the work; that outside the introspections of the art world, the involvement and interplay of contemporary society as it embraces or rejects the effort to make art, is the art.

Through the trials and tribulations of this piece new thoughts and ideas began germinating. For a period of time, during and after Kaplan's visit, we discussed the idea of a possible attempt at a large portrait of the Statue of Liberty somewhere in the center of the country. The idea was to promote the view of

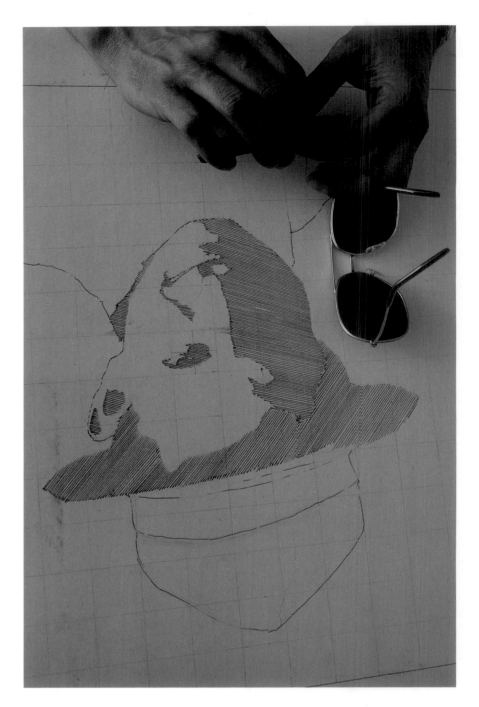

The graphic gridded sketch is mounted on a panel on the tractor for quick reference when laying out the image.

common ownership of "The Lady" by the entire country and not allow it to continue as just an icon of New York. He eventually became overwhelmed by his task of documenting the statue renovation project, and my efforts to sell the idea in Kansas went for naught, so the effort was abandoned. But, as will be seen, the idea popped up again two years later—this time in much different form.

MEDIA-DEPENDENT ART

The subjects of my first two images, Satanta and Will Rogers, had given me an opportunity to shift somewhat the focus of media interest from myself to the personalities and historical significance of the two men whose lives and philosophies seemed to anticipate some of my own attitudes toward contemporary issues. The Kiowa leader was a fitting symbol of the struggle by free men to avoid being confined by a system instituted by men in power, a system which eventually swept away his way of

life and that of his people and led to his suicide. Will Rogers, with humor and unpretentious insight, leveled a less threatening attack on the class system, on bureaucracy, and on the ever more powerful government of a growing America.

Most of the spring and early summer of 1983 was spent transiting between Red River, New Mexico (a small town north of the historic artist community of Taos), and Dodge City, Kansas, while I struggled to save the *Will Rogers* portrait. In July of that year, I moved from Red River to eastern Kansas. Janis Light, then my companion and soon to become my wife, accompanied me in the move. We settled in the city of Lawrence, where we continue to reside. At that time I began focusing my energies on the idea of a third earthwork. In retrospect, I now see that my life followed a definable pattern as I approached these large undertakings. Invariably I would exhaust myself physically and financially, supporting the cost of these efforts with the sale of commissioned easel paintings and a variety of (traditionally imaged) mural projects, and would then retreat into a winter of introspection and self-doubt.

The central struggle in my life as an artist involves two seemingly unrelated but, in fact, closely related issues: the question of media dependency, and the problem of financing production of an essentially impermanent outdoor art that cannot be collected or sold *per se.* Early insecurities with my then-incomplete artistic vision, and a limited understanding of the contemporary art scene at the time, merely added to my concern about an increasing number of calls coming in from promoters of popular television shows featuring the bizarre and unusual who seemed to be viewing the work as a rural-America eccentricity. The question I pondered: can an art form embraced by the masses and by those in the mass media, many of whom know little about art, possibly be categorized as "fine art"? An artist perhaps should not be concerned with that but inevitably is. Yet art critic Hilton Kramer has written that popularity cannot be cited as a standard of achievement in art.

By the beginning of the third earthwork, it was becoming clear to me that I could pick and choose who would be involved in my work, and to some extent how it ultimately would be presented and treated. I also came to view those who filmed, photographed, and wrote about the work as collaborators who, sometimes without realizing it, became an integral part, an intrinsic and essential element in the final presentation of the artwork. My relationship with all collaborators and sensitivity to their skills, along with my own ability to subtly control results, would inevitably be present and perhaps discernible in the final production.

I have observed that the media are fairly adept at gauging the extent to which they are being manipulated, whether by artists or politicians. I have been generally pleased with media "snapshots" of what my work and my life are about, but because they are so personal, both may seem at times surreal. This is especially true when processed through camera lenses and when encountered in the written and spoken words of reporters. But mostly, with few exceptions, the media has been sensitive to my work.

That my work is dependent on media dissemination can be judged either as an inherent failing or as an interesting or even defining aspect of an art that is the inevitable result of an increased dependency by the populace on both print and visual media for intellectual insights and as sources of information. West coast art critic Ralph Rugoff wrote in the *Utne Reader,* "Although artists throughout history have been able to stand outside society, secure in their ability to define art and offer social commentary, today they can fill no such vital role. Artists are more marginalized than ever and, these days, marginality means being trapped inside the media culture struggling to be heard, rather than being a pioneer on the fringes."[2] I would suggest that while artists may or may not be in a trap, the relationship to, and dependency on, the media probably *is* a new reality.

As national and international media attention focused on my efforts, I found myself in an intriguing dilemma. Because the earthworks have usually been presented as serious work by a serious artist (while at the same time relating to the masses), I believe that my work has embodied at its core the essence of critical discussion about popular art versus fine art. Also important in that discussion are the questions of media influences on art, an artist's influence on the media, and finally, the influence of media and artists together on popular culture in general.

Most of my generation has grown up sharing a ubiquitous primary source of information—television. When people began to assimilate information as if by osmosis, to see the world through a single all-encompassing media eye, a new era had dawned. A cultural playing field had been leveled, so to speak. Young people growing up in the Bronx and those coming of age in places like Protection, Kansas, were sharing the same imposed world view. For good or bad, we recognized the same figures as heroic, digested the same news, and were beginning to share a single national view of our country. America was changing, and we held similar understandings of its influence on the world. Not surprisingly, my first impressions of the art world had come through that shared television screen. Later, when stories about my work began to appear in national print and on that same screen, it was both exciting and more than a little frightening.

Articles on my work ironically appeared in the same week in November 1986 in both the *Wall Street Journal* and the *National Enquirer.* I couldn't help but reflect on the remote likelihood of a single reader happening on both stories. Whether as grist for praise or for condemnation, my art has appeared in an extremely diverse selection of newspapers, magazines, photography books, and other media forums. Many national art magazines have run articles of varying length about my work. It has been featured in international farming, gardening, sustainable agriculture, aeronautical, outdoor, and environmental magazines; on radio and television; and in newspapers around the world. I am especially pleased with the number of children's periodicals that have published the work as a learning tool, and gratified that the images are finding their way into children's textbooks. In many ways, the diversity of the publicity has a long-lasting positive, even heady effect, but it only takes one negative remark to bring one back to earth: for example, when a columnist in *Arts* magazine made mention of crops planted in fields as an example of art that the (obviously misguided) national news media covers rather than paying proper homage to "important" works of art.

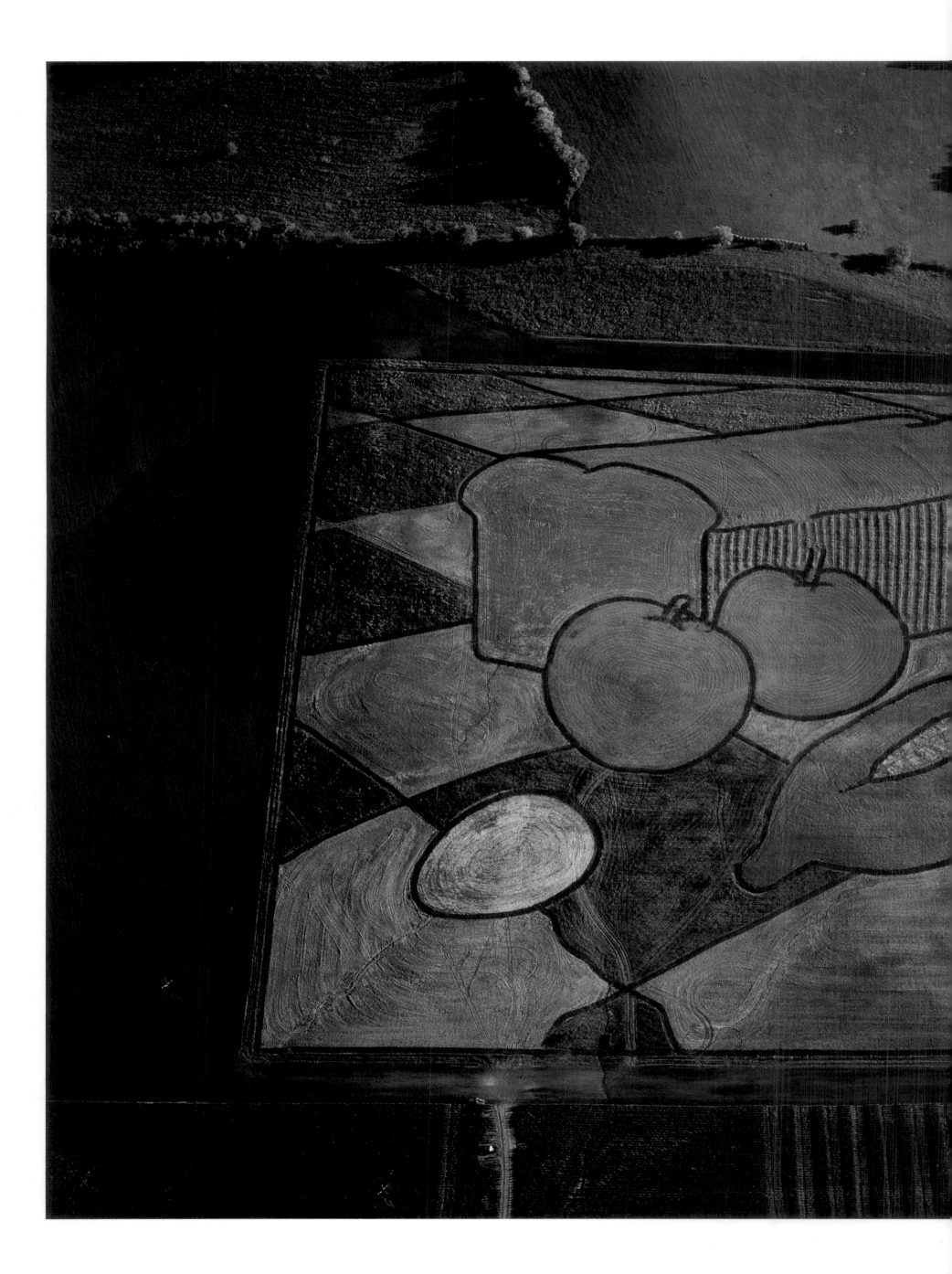

Still Lifes

Herd's *The Harvest*, influenced by the still lifes of Cézanne, at its peak in the summer of 1987. The image, near Lincoln, Nebraska, is planted with wheat, corn, and field grains.

SUNFLOWER STILL LIFE

My sixties idealism, falling away in the face of my own assimilation into contemporary society, gave way to a less strident and simpler form of expression. In 1985 I decided to attempt a field still life with all energies focused on my resolve to *this time* successfully plant an image with an array of separate crops. I wanted to cease exploring the philosophical and political and begin exploring technique and style as it related to earthworks—to art. With the first two field images adapted from historical photographs, it became important to me that the third be an original image, emanating from my own artistic style.

The *Sunflower Still Life* evolved from a painting of a potpourri of objects which included a vase, items of produce, and bottles composed on a quilt. It was painted in three sessions in a two-day period of time. I then began to subtract items in a subsequent sequence of drawings and paintings during ensuing weeks until I ended with a graphic painting of a vase with five sunflowers centered on a checkered tabletop. From this evolved the final artwork suitable for a field image. A final pencil drawing, with only three flowers, was overlaid with a grid. Each one inch was scaled to one hundred feet on the field. I then mounted the working drawing on a sturdy board. Thereafter it was carried with me on the field as I worked with transits and two or three assistants to begin transferring the grid to the field.

In a 1986 interview, I mentioned that while I was in the process of laying out my *Sunflower* field, I had researched Vincent van Gogh's Sunflower series painted in Arles late in his life. After that it was impossible to change the perception, erroneous though it was, that I had attempted to copy one of Van Gogh's paintings. The French magazine *Le Figaro* heralded "Le Van Gogh du Kansas," reproducing in the article a small photograph of Vincent's most famous painted flower arrangement for comparison. Ironically, this same painting sold for a record art world price two years after my earthwork.

The perception of my work as something other than original art was disturbing to me. The graphic image I had incorporated into the field conformed entirely to my own original concept, in both design and presentation.

The idea of a graphic still life had evolved over two or three years and issued from many sources. One of the most important influences was a growing recognition of the historic American quilt as an artform. This view was reinforced from time to time as I watched my mother, a quiltmaker, pursue the manipulation of colors and designs within a framework of established patterns. There was something fascinating about that freedom of expression within parameters of a larger traditional design. People involved in quilt-making may not create something entirely original outside that traditional framework, but their ability to manipulate hundreds of components to their own vision, choosing from thousands of colors, designs, and patterns, obviously satisfies their own individual creative needs. Most artists also operate within some sort of traditional prescribed framework.

Another source of inspiration came from visits in 1984 to the studio of Fred McCraw. Working with sketches from field trips, McCraw painted representational landscape images which early

on were reduced to hard-edge abstractions. That series of abstractions issued from a process of sequential deconstruction. His technique of a painting evolving from the previous painting gave me direction in the process of simplifying my preliminary still life image, leading through a series of images, to the graphic hard-edge field sketch.

Members of the Neis family, third- and fourth-generation farmers near my home in Lawrence, were willing and generous art patrons. They responded positively to my proposal, inviting me to "pick a field and get after it." The Neises, and subsequent participating landowners, seemed to understand that I held their occupation in high regard. Most, it has seemed, were genuinely surprised to meet an artist who also knew how to run a tractor and talk *their* language.

After initially etching out the still life in the fall of 1985, too late to plant, the design came dangerously close to meeting the same fate as my two earlier earthworks, as my determination to incorporate crops into the image was almost frustrated once again. As spring approached I reluctantly decided at one point to give up on the field because of concern about the negative financial effect of the artwork on myself and on the Neis family. I thought it an imposition to hold their ground out of production. Those thoughts grew from my distress over a combination of setbacks.

The greatest of these had been a series of barely affordable trips to New York made in an attempt to pursue an image being considered by the Trump Organization for a site on the old Penn Square Railroad grounds on Manhattan's west side. Trump had targeted the site for a major building project in the near future. His people initially agreed to lease to me, at the cost of one dollar, fourteen acres for a period of time to produce a temporary image.

I had originally approached them without a specific image in mind for the site. The Trump people, focused on the upcoming Liberty celebration only six short months away, locked on the idea of a Statue of Liberty portrait that Kaplan and I had discussed in 1984, and thereafter specified *that* subject matter for the fourteen-acre plot. I was not excited about doing a "portrait" of the statue by this juncture, because the whole event had taken on a circus atmosphere with likenesses of the statue on every conceivable item from candlesticks to condoms. I had hoped to make my New York debut an original art statement, not a paean to an icon. Efforts to raise funds for a Manhattan Island work proved unsuccessful and time to pursue creation of the image ran out. In the process, the *Sunflower Still Life* was neglected.

As with earlier pieces, the still life image had initially been brought forth on the land using subtractive methods of mowing and plowing. As the landowners needed to commit the ground to a cash crop in early spring, they had to know soon if I intended to abandon plans to plant the image. Within a week of the time when that decision would be necessary, calls from CBS's Charles Kuralt and from producers of Turner Broadcasting's *Portrait of America* convinced me to salvage the work and go forward with it. Their interest had given me a reason, but not the resources, to persevere. With strong encouragement from the Neis family I decided to proceed under circumstances so pressing that it eventually became necessary for my wife and me to sell our small

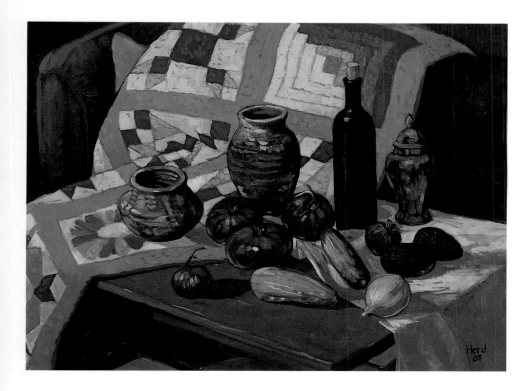

The process of designing the *Sunflower Still Life* grew from a series of preliminary works, starting with a painting that included the vase and the quilt.

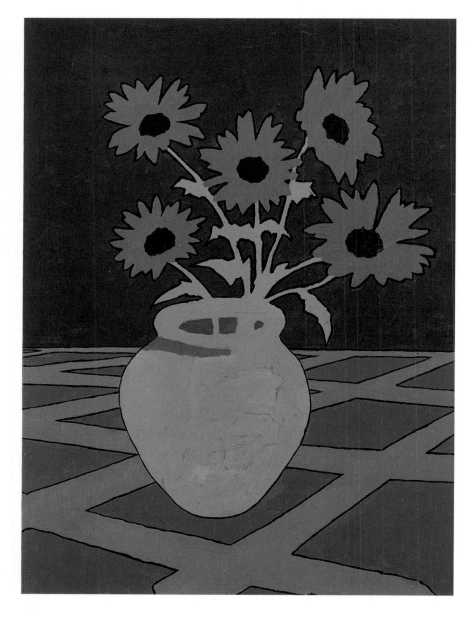

The final still life painting with five sunflowers.

house and move into an even smaller one. At that point media interest obviously was leading the effort to continue this earthwork, in a sense directly influencing an art on which they were reporting, but I had become comfortable embracing the support of others. At that time I was willing to accept inspiration and other assistance from whatever sources availed themselves.

Kuralt came to Lawrence, completed an initial filming slotted for the *CBS Evening News*, and then suggested a follow-up trip in the fall if I was able to successfully plant the giant graphic sunflower designs to actual domestic sunflowers and bring them to full color. Kuralt and his crew had filmed what amounted to a "working drawing" in early spring. They came back to film the "finished painting" in late August, just in time to capture the brilliant yellow sunflowers at their peak.

Daniel Dancer arrived on the scene during the initial stages of the still life with a welcome offer. At his own expense, he would begin documenting the process and record stages of the work as it progressed. For the next five or six years we would be together many times on and over my evolving fields as he captured subtle nuances and seasonal changes of each successive earthwork. Dan's photographic perspective and eye for composition gave further credence to my concept of the earthworks and their documentation as being a collaboration involving multiple participants. His diligence in photographing the images from ladders and other interesting vantage points led to a traveling exhibit of thirty-one photographs of four of my earthworks. That exhibition, *Fields in Focus*, is at this writing completing a third year on tour.

Increased national television coverage of the *Sunflower Still Life*, and the fact that it had been documented by a number of top photographers, resulted in the image finding an audience around the world from Europe to Sri Lanka, from Japan to South America. Swiss photographer Georg Gerster, thought by many to be the world's premier aerial photographer, made a photograph of the still life that ended up in opening pages of the ambitious 1986 photographic extravaganza *A Day in the Life of America*.

Process

From the time of my first representational earthworks, I have explored the possibilities of field art techniques as they are defined for me by the limitations of man-made tools and machines. As with conventional tools of artistic expression from finger-painting to the brush, chisel, pen, and printing press, subtractive farming methods such as mowing, discing, and manipulating the earth for texture and contrast have, in combination with orchestrated plantings, established practical limits to my exploration of field imagery.

The first order of business, of course, is selection of a field. Scouting for fields for particular projects begins after contacts have been made with willing landowners, who then usually lend me maps designating particular fields, each with its own peculiarities, from soil type to accessibility. Next come numerous flights to view and photograph the possible "canvases" to discover any anomalies such as ravines, ridges, sink holes, or soil discoloration. When

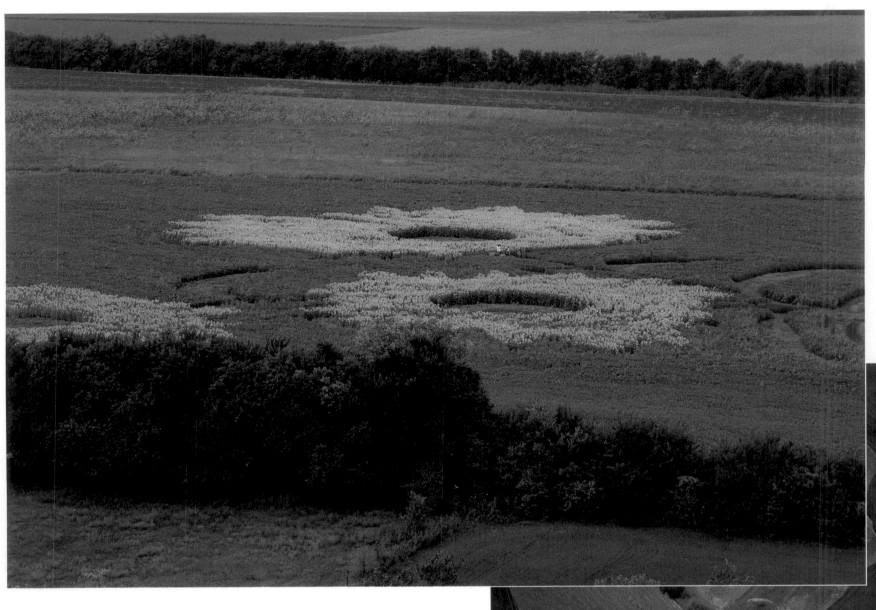

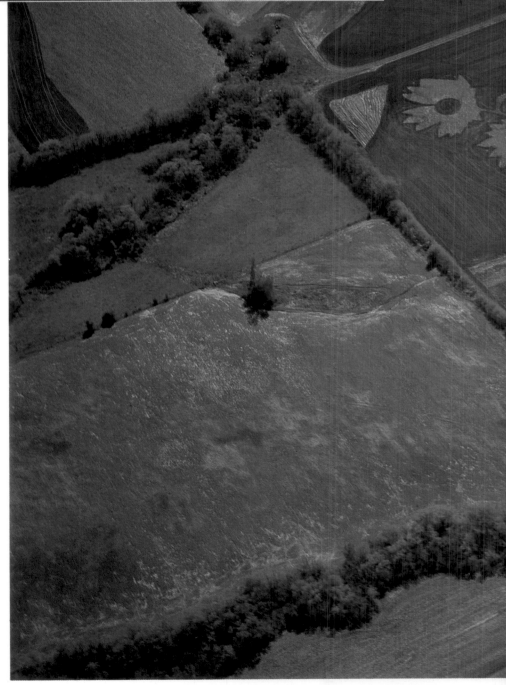

Above: From two hundred feet the
sunflowers dwarf the tree row in the
foreground.

Opposite, above: *Sunflower Still Life*, with
three flowers, was initially etched out of a
clover field in late summer of 1985.

Right: The more colorful still life just prior to
planting in late spring 1987.

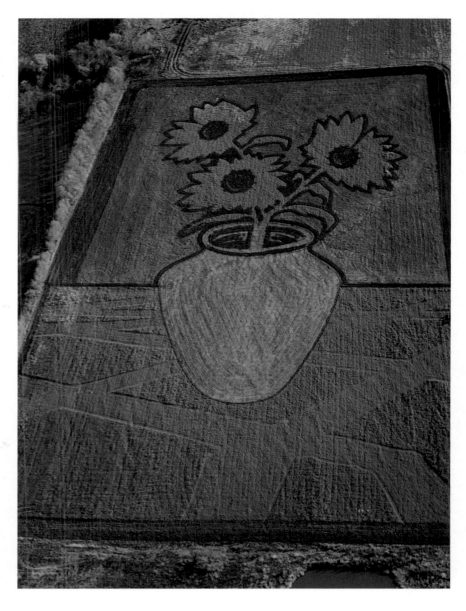

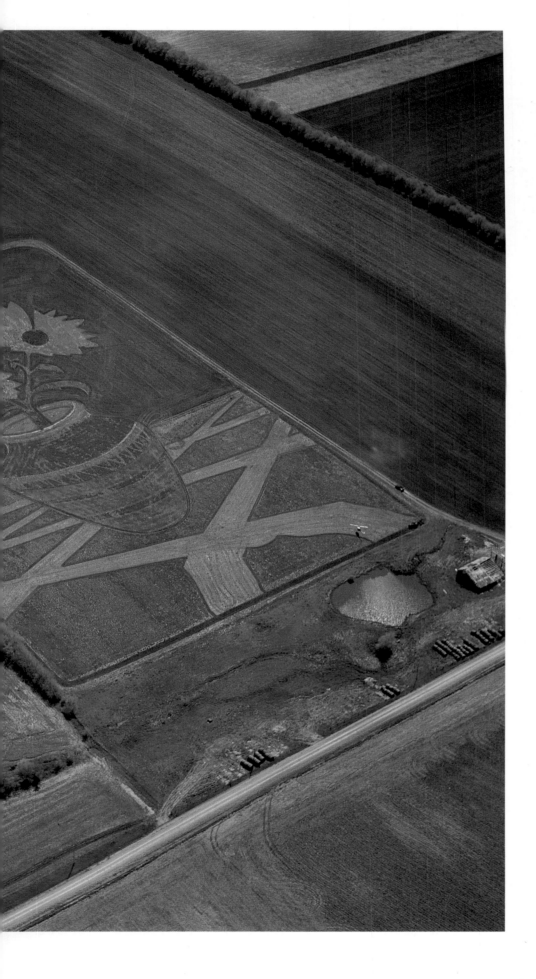

a field is chosen I then walk it to get a feel for the ground and attempt to visualize the image onto the terrain.

Artists, especially muralists, have long utilized a basic grid to project a smaller sketch to larger dimensions. A grid is best described as a network of uniformly spaced horizontal and per-pendicular lines used for locating points by means of coordinates. On my large images, as noted earlier, the scale I usually use is one inch on the sketch representing one hundred feet on the field. In areas of more intricate detail I often drop the scale to fifty-foot intervals within the larger grid, sometimes even smaller. At each coordinate on the field I place a flag, which I identify numerically to correspond to the proper coordinate on the sketch. There is no margin for error in this early stage. To lay out the giant grid accu-rately I prefer to use at least two assistants to walk with one-hundred-foot tape measures to set the flags at coordinates found through the lens of a surveyor's transit. For those unfamiliar with the device, a transit is a telescope mounted onto a tripod or axis. It utilizes right angles for purposes of exact measurement over distances.

Once all flags are positioned and numbered I approach the field from a logical entry point, as it relates to the sketch. With flags of another color, I establish my line of entry by measuring from found points. It's like reading a simple map. Sometimes, if that field has existing vegetation, I am able to mow a very discreet line. That gives me an opportunity to view initial lines of the work from the air without committing the image permanently.

My approach to a field probably is closest in method to that employed in the fine art printing process with parallels to

intaglio techniques. Once I am satisfied with the initial lines, I commit the image to a disc or plow. A disc is a piece of equipment with two sets or banks of sharp-edged circular discs rotating on a shaft. The front bank cuts into the ground and rolls the top soil and vegetation in one direction, while the second bank follows and turns the material back, thus chopping the vegetation and breaking the ground up to prepare for planting. The plow, on the other hand, gouges out a deeper furrow, thus ripping the root system out and bringing up rich soil from eight to twelve inches down. For my purposes, the disc gives me a shadowing technique because it mixes and chops the vegetation but leaves it somewhat visible; the plow is used to outline and sharply define the image.

After etching a design, the process of flying over the work to capture transient stages begins. (Because of weather and other factors the field can change almost daily.) With the help of assistants (pilots and photographers), I begin to pull "proofs," in my case photographs, to calculate a successful line before considering further sequential treatments. At times during this information-gathering stage, I may draw on the face of photographs or otherwise manipulate them or pursue the production of related images in a number of traditional art mediums. These activities may lead to involvement with agricultural specialists, farmers, and others with whom I consult for information ranging from local geographic seasonal constraints to soil viability and crop selection.

Below left: The image is retouched throughout the year to complement significant changes occurring in the maturing crops.

Below: The artist views the work from a twenty-foot ladder.

Below right: The artist maneuvers the tractor while monitoring progress with the gridded field sketch.

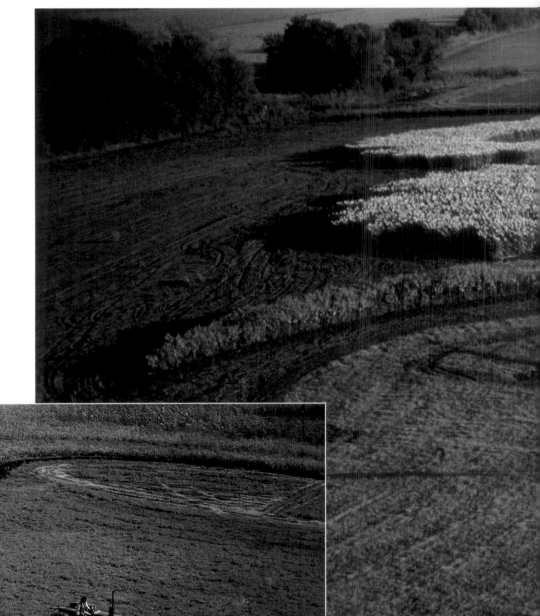

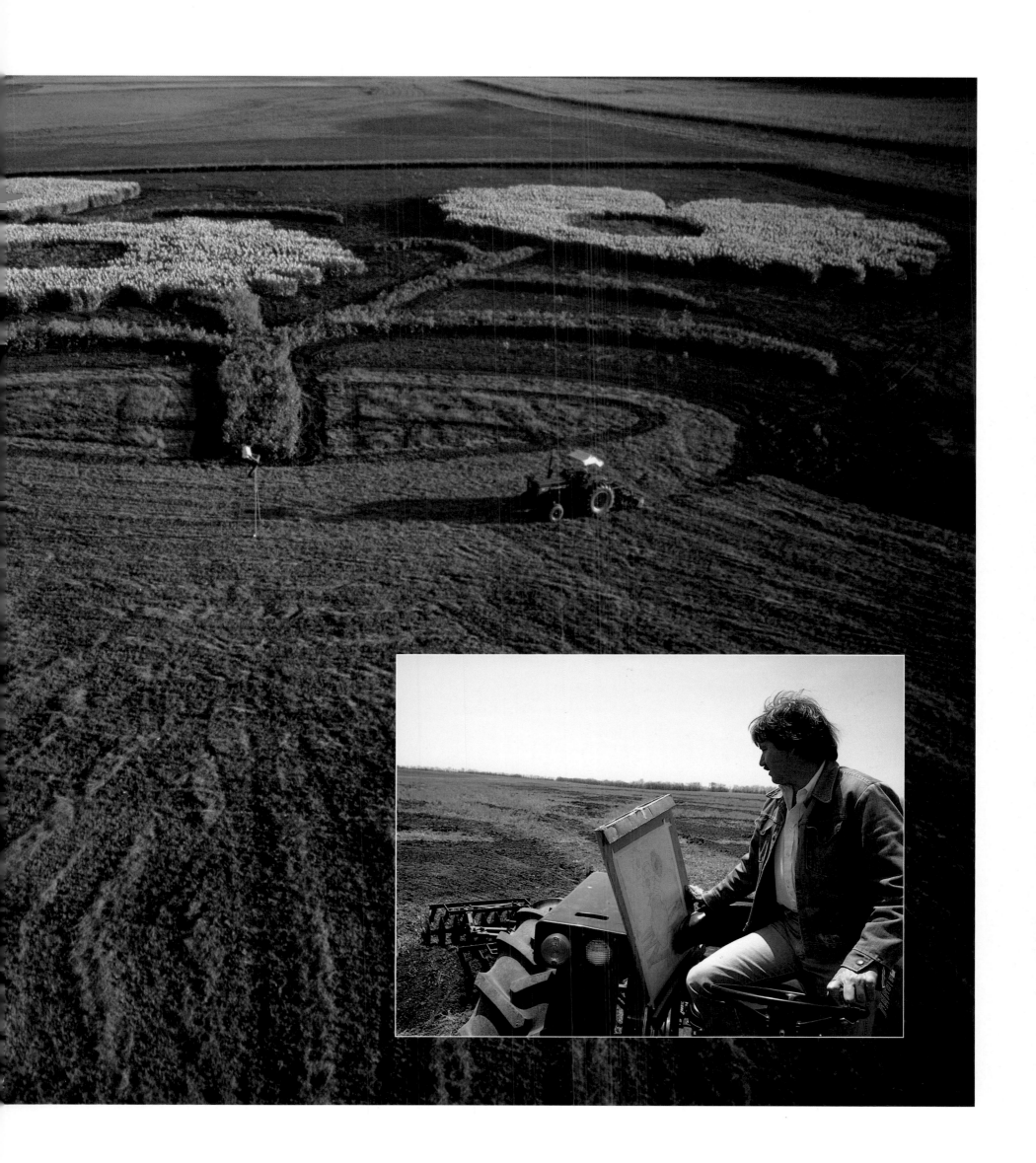

Although the field image is always transient and transforming, evolving or fading as plants reach maturity and are harvested or drop their seed and return to dormancy, there are peak times when, because of colorful stages or natural crop maintenance, I am most intently involved in manipulating it. In these peak periods the need to coordinate my activities with photographers to capture the process is sometimes critical. For example, a complicated work-over coordinated with the flowering of the domestic sunflowers in the *Sunflower Still Life* would yield a very different picture if photographed at sunrise rather than over-exposed in the noonday sun. Also, with the giant yellow petals of the flowers clinging to the head of the plant for only eight or nine days, the window of opportunity to capture the image can be greatly impacted by inclement weather or equipment breakdowns.

Because of shadow and backlighting considerations, the way a field piece lies as it relates to the rising and setting sun greatly affects how we approach the image to photograph it effectively. All the images have in common a bas-relief effect with some plantings reaching shoulder height and with accent lines etched as much as a foot deep. As stated earlier, Dan Dancer brought a new level of enthusiasm into the process of capturing transient stages, sometimes camping out on a field to capture a sunrise, or hanging out of an airplane window in winter to record a snow-covered image.

Sunflower Still Life Revisited

Success of the colorful *Sunflower* image in 1986 had been exhilarating. The Neis family had enjoyed the media events and a newfound notoriety. They had not hesitated to leave the still life in the ground, and with that decision had come a first opportunity to deal with an existing earthwork through the dormancy of winter. With spring approaching and a film production crew on its way from Tokyo to record the image for Japanese television, we decided to renew it for one more year. My main interest was to attempt to address what I considered weaknesses in the earlier planting.

I wasn't particularly happy with the solid background in the 1986 work, having reservations about whether it succeeded in providing depth to the composition. Also, rather than repeat the previous year's attempt to establish a three-dimensional quality to its shape, I wanted to try a new approach to the vase, keeping in mind an earlier decision to maintain broad patterns of color and texture whenever possible. I was being given an opportunity to pursue the image further and decided I would expand my experimentation to the degree that finances and time would permit.

Don Lambert, a friend of Kansas artists in the state capital of Topeka, is an outspoken lobbyist for matters artistic. In the fall of 1986, Don suggested that I approach some corporations to search for common ground between artistic needs and corporate needs. Kansas Farm Bureau, a state branch of a large insurance and farmer-based corporation looking for a way to show support for farmers, financed the printing and pursued the marketing of a large number of fine art posters of the *Sunflower Still Life*. Half of the proceeds were earmarked for the Agriculture Hall of Fame in nearby Bonner Springs, the other half for me. They received a truckload of good press from around the state. Funds from my share of proceeds gave me the financial ability to replant the *Sunflower Still Life* in 1987. Thus my second experience in dealing with a large corporation was a gratifying one.

Art and Agriculture

As with the work of Christo and that of all earthwork artists, such as Heizer, Smithson, and DeMaria, I am constrained by weather, which is the wild card in any attempt to "create" in the natural landscape. My efforts, because they involve plantings, are especially at the mercy of the vagaries of weather. Early on, those frustrations had been overwhelming. I began to take personally the record droughts and odd seasonal patterns that wrecked weeks of work and left me with infestations and stunted plants. I was sharing the spiritual essence of the farming experience in my struggle to make art. I was finally beginning to understand the fact that my art reflected those farming successes and failures.

By the time of the 1987 *Sunflower Still Life*, I had been pursuing the earthwork artform for eight years. I was becoming much more comfortable talking about my work in terms of art and the art-making process, in part because I was continuing my studies in art history. Janis was engaged in seeking an art-related degree at the University of Kansas, and we immersed ourselves in art seminars, activities, and classes. Lawrence, located twenty-five miles west of Kansas City, likely has as many artists per capita as any city in the United States and is very active in support of the arts and other cultural activities. Along with those artistic influences on my earthworks I was beginning to grasp the concept that my field images might become a platform from which to discuss the issues at stake in modern agriculture. This evolved from an introduction to philosophies taking shape at the Land Institute in Salina, Kansas, where founders Wes and Dana Jackson were beginning to make small ripples in the consciousness of mainstream America. An opportunity to meet the Jacksons and speak about my work at the Land Institute in 1987 had a direct and profound effect on my work. Wes Jackson's message calls for a reform in modern technological agriculture and a return to "natural" farming. In a review of one of Jackson's books, *Altars of Unhewn Stone*, Lewis Hyde, assistant professor of English at Harvard wrote, "I began to wonder if there hasn't been an odd inversion in what might be called the geography of intellect. We have long imagined the city as the natural home of radical thought. But now almost everyone has moved to town, and the roles have been reversed. Maybe now it is the three percent working the land who are positioned to see and to tell us about the dark side of our mythologies."[3]

One important aspect of understanding contemporary issues shaping society is, I believe, the realization that agriculture is viewed by most Americans as having little or no impact on their lives. No myth could be further from the truth. It is the contention of many that the collapse of rural America is central to social and cultural problems in America's cities. The neglect of rural America parallels our historical neglect of the environment and of the original indigenous population.

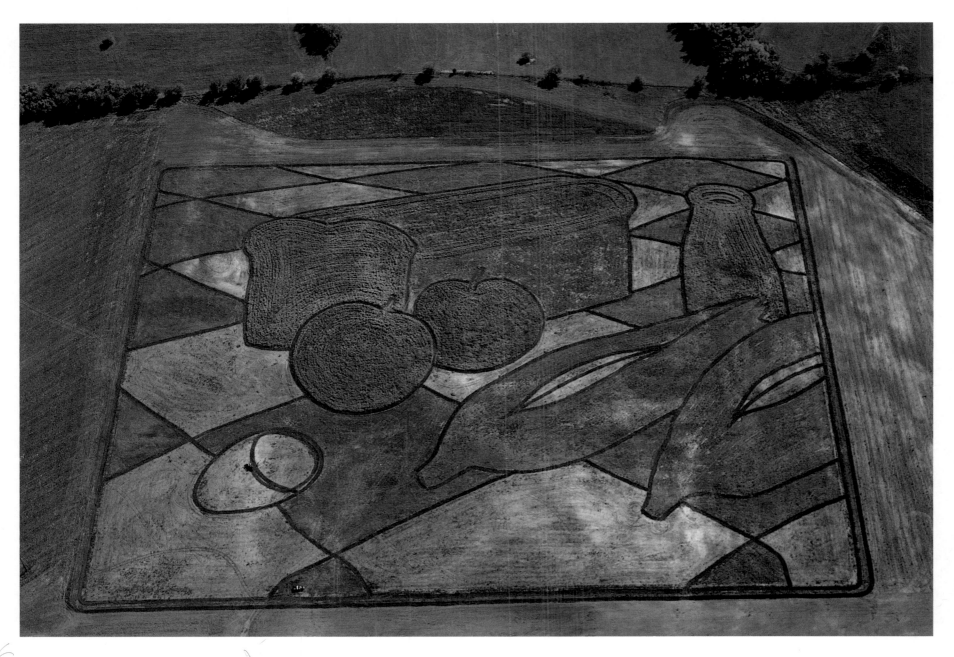

The Harvest in midsummer of 1988, after extensive replanting of corn, milo, and wheat on most of the design.

THE HARVEST

On a number of levels, the earthwork titled *The Harvest* was my most difficult. It was sited in Lincoln, Nebraska, the state's capital and political nerve center. The involvement of politicians made it possible but, paradoxically, also made it very difficult.

Lincoln is a bustling city of 200,000 energetic folks in the midwest farm belt, known for great college football, farming, and high-tech agribusiness. My crew and I traveled the more than two hundred miles from my home in eastern Kansas some forty times in two seasons to coax a still life out of the stubborn soil of eastern Nebraska.

The Harvest image, although more graphic than Paul Cézanne's canvases, reflected my attempt to incorporate pictorial devices he pioneered, namely rendering depth in place by overlapping forms and color. Cézanne suggested that a picture should exist as a flat design before it creates a three-dimensional illusion.[4] The desired result should be to see depth and pattern at the same time. The twenty-four-acre Nebraska image was drawn from my imagination but with a specific elevated view of the subject matter which paralleled that seen in many Cézanne still lifes.

In the fall of 1986, with the *Sunflower Still Life* at a peak,

an invitation from State Senator Bill Harris opened the door to this first image away from my home state of Kansas. At that time, with the New York project having fallen through, I became even more interested in expanding my horizons by pursuing work outside my home base. I also was excited by the fact this might be my first commissioned field piece, and it appeared as though I would be able to retain control of its artistic content. I met with Senator Harris and his brothers that fall to discuss possible approaches and locations for an earthwork near Lincoln.

The following winter, while this effort was still being considered, I received a call from a group working with Farm Aid III, the latest in Willie Nelson's ambitious series of concerts designed to help raise money and heighten public consciousness of beleaguered farmers then struggling for survival throughout the Midwest farm belt. Nelson's associates invited me to come to Austin, Texas, in early spring, where I met with his concert producer. We talked at length about my earthworks and how they could relate to the concert, which was then being tentatively targeted for the city of Lincoln.

It appeared I now had two support groups, at least in spirit, for the same artwork. Yet because of Nelson's outlaw image, some factions in Lincoln did not take to the idea of a gang of renegade musicians performing on the "sacred grounds" of

29

Above: A crew of helpers operates from a truck to help spread grain just prior to the Japanese film crew's arrival, September 1987.

Right: The tractor follows the border, preparing to reenter the field to outline the milk bottle.

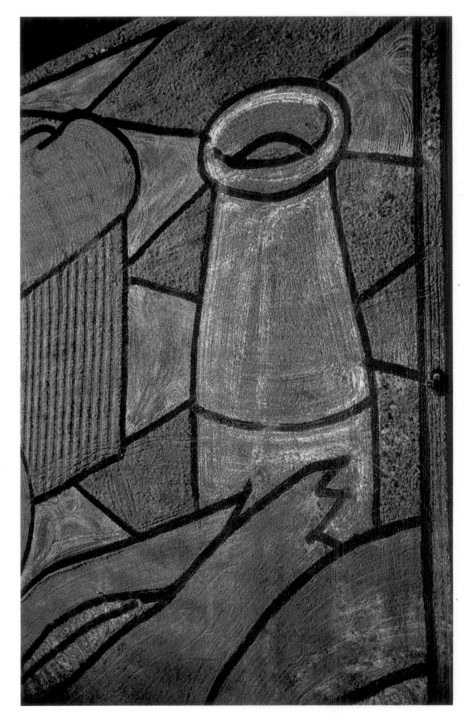

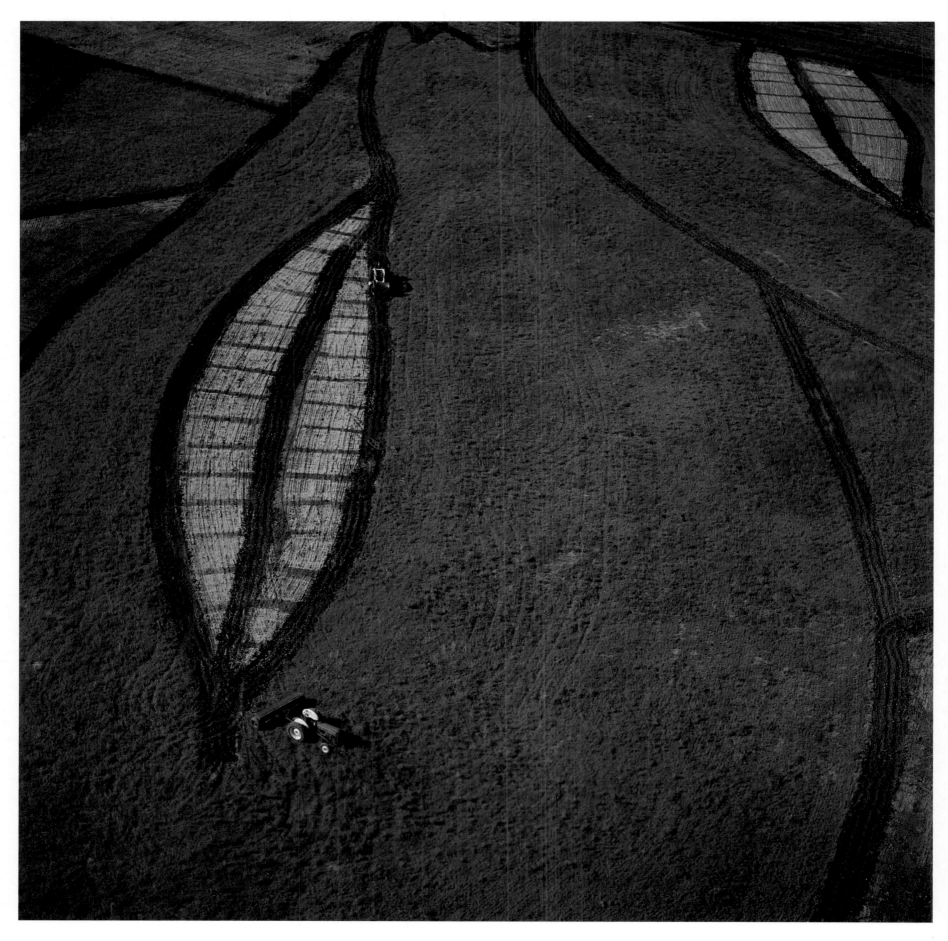

The giant graphic ears of corn were actually
planted with wheat, with the corn kernels
formed by real kernels of waste corn
scattered on the ground.

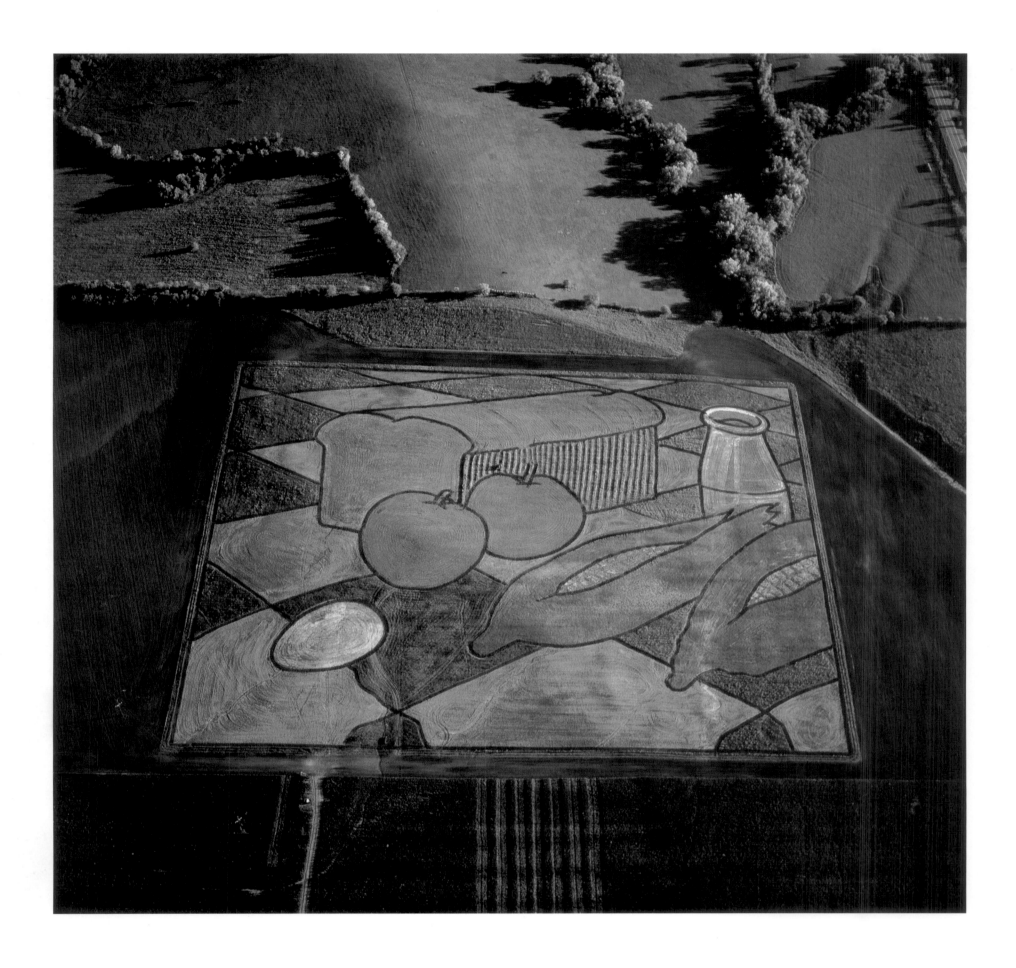

Three days after the Farm Aid concert, *The Harvest* image reaches its peak. The large white areas of the quilt are the result of crusted-over ground after a three-inch rain.

Nebraska stadium. With politics creating an atmosphere of doubt, the concert came very close to going elsewhere. Bill Harris, who only days before my trip to Austin had been elected mayor of Lincoln, was a staunch supporter of Nelson and the concert. I am inclined to believe my efforts to put the promoters in touch with the mayor at a critical juncture in negotiations helped secure the Lincoln site. It was a pyrrhic victory. The promoters who were attempting to raise money for my earthwork found themselves the target of a gigantic fund-raising request from Nelson. It consumed their time and talents and the city's financial resources.

Through seemingly heroic last-minute efforts, long after the image had begun, funds were found and directed to me through a nonprofit company called the Lincoln Haymarket Development Corporation. This company, which had renovated an old downtown warehouse area into a thriving community of upscale

shops and restaurants, enjoyed community-wide backing and also had historical ties to agriculture, which made it the most logical of available nonprofit corporations.

Thus began a traumatic involvement with a bureaucracy, with politics, and with the diverse personalities who *collectively* controlled when, if, and how I might receive money that had been promised for my earthwork. From issues such as private attempts to commercialize the image, collection of targeted funds, and copyright ownership of the artwork to issues of concert promotion and a Japanese television show's filming deadline, the result of engaging a nebulous many-headed patron was often chaos and misunderstanding. In addition to the Harris family, Fred McCraw and Lincoln lawyer James David Thurber pitched in to control that chaos and worked to help secure the integrity of my image.

Because I was away from home and had committed myself to a "completion date" to coincide with the Farm Aid concert, I had to become more aggressive in pursuing essentials needed for *The Harvest* image. Among the first of many who happened into my path were the Beckmans, a father and son farming duo from nearby Malcolm, Nebraska. I drove the Beckmans' equipment back and forth the ten miles between their farm and the site for three or four months, ate their food, and accepted their generous offer of housing during most of the project. They rousted out their friends and family to help locate needed equipment and materials and were the first on the field when I needed helping hands. Amazingly, they still return my phone calls.

With only four days to go before the concert, the field was inundated with a hard-driving three-inch rain. Communication with the Farm Aid people had become nonexistent as they busied themselves with their own deadline. Adding to the troubles, the Japanese television crew had made plans to film the image on the morning of the day of the Farm Aid concert. For me, Lincoln at that moment approached and then passed beyond the point of critical mass into confusion.

A flight over the field after the downpour revealed a dark and very low-contrast image. Twenty people with hand tools and small equipment helped for three straight days in an attempt to embellish the image with some strategically placed grain, straw, and lime to highlight color and form in the artwork. The incorporation of color by adding nonplanted organic matter was not part of the original plan. At the time I viewed it as undesirable, but I felt I owed the patrons a successful image on the appointed day of the concert. Efforts to that end were intense. An army of volunteers showed up; some had responded spontaneously to radio appeals for help, freely giving their time and labor for art.

Yet, to my knowledge, no one with the concert entourage ever saw the work. Also the Japanese were more than a little disappointed with the poor definition of the image. They had arrived, one hundred strong, filmed a one-hour television production from the field, included aerial shots of the image in their footage, ate a barbecue supper in the middle of Nebraska milo fields, and, at day's end, climbed aboard airplanes and flew off into the sunset.

Two days later the ground dried out. I outlined the image with rich dark soil by plowing into the light-tan crusted topsoil

and had a spectacular result. Almost no one was on hand to view it. The photographs that Dan Dancer took that day when the work was at its peak are here reproduced. They reveal a tractor path leading into the center of the image. That path had been the access route frantically used to haul loads of grain and other materials onto the field.

The most disconcerting aspect of the Nebraska project was that so many people threw themselves into this effort that I literally could not keep track of them. Communication with them was intermittent and inadequate. When finished, I went away feeling I had failed them. Somehow, they deserved more from me. The one important victory in this frustrating episode was the success of the art itself. It had worked well. I was happy with the image, which remained through two growing seasons.

This experience led to an important decision—never again to involve myself in a work more complicated than I was able to control, nor in one for which funds had not already been secured. However, my resolve was short-lived. As things turned out, I would come close to repeating the same mistakes the following year!

THE LAWRENCE AIRPORT "HAPPENING"

On Sunday, September 20, 1987, the day following the Farm Aid concert, the city of Lawrence dedicated a new airport terminal building. The *Sunflower Still Life* became the focal point for an all-day dedication, an "art happening" organized by the Lawrence Chamber of Commerce and the Lawrence Arts Center. "Art Flyovers," ten-minute round-trip flights to view the still life, were made available to all comers for the low price of eight dollars per person. Hundreds showed up to wait hours for the flights.

Many private pilots, members of an association in Lawrence, participated. Their fleet of planes varied from two- to five-seaters. The fee included nothing for the services of the pilots—it barely paid for fuel—yet the pilots probably worked as hard as they ever had in keeping to the schedule to circle the *Sunflower Still Life* eight miles away near the community of Eudora, and return for a new group. The day was treated as a family outing. Children were abundantly present, many anticipating a first airplane ride. On that sunny September day, more than five hundred people viewed the art piece as it was being transformed by the onset of fall.

Inside the terminal building, the sponsors had filled available wall space with preliminary drawings and oil studies of my field art pieces up to that time. As complete an exhibition of those works as has ever been mounted, it enabled viewers to better understand the process that is followed in developing fieldwork images. A few studio paintings were displayed as well.

The media were present and waited in line with other passengers for their turn to see the artwork "in person." I had managed to grab four hours sleep before driving back to Kansas from Nebraska to meet participants in the "flyover." The exhilaration of the day combined with my fatigue to give the affair a rather surrealistic quality for me. I slept for close to twenty hours when it was over.

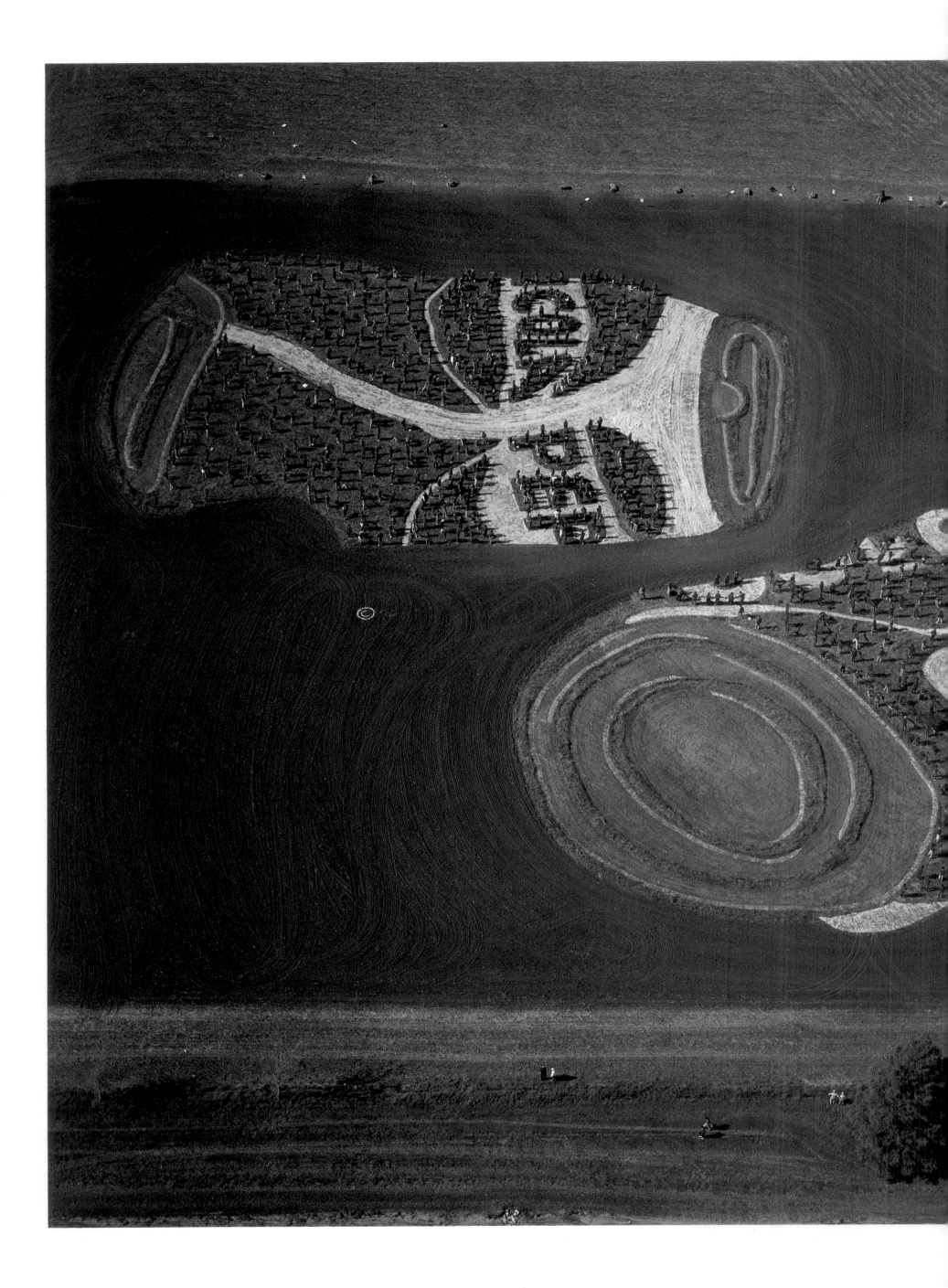

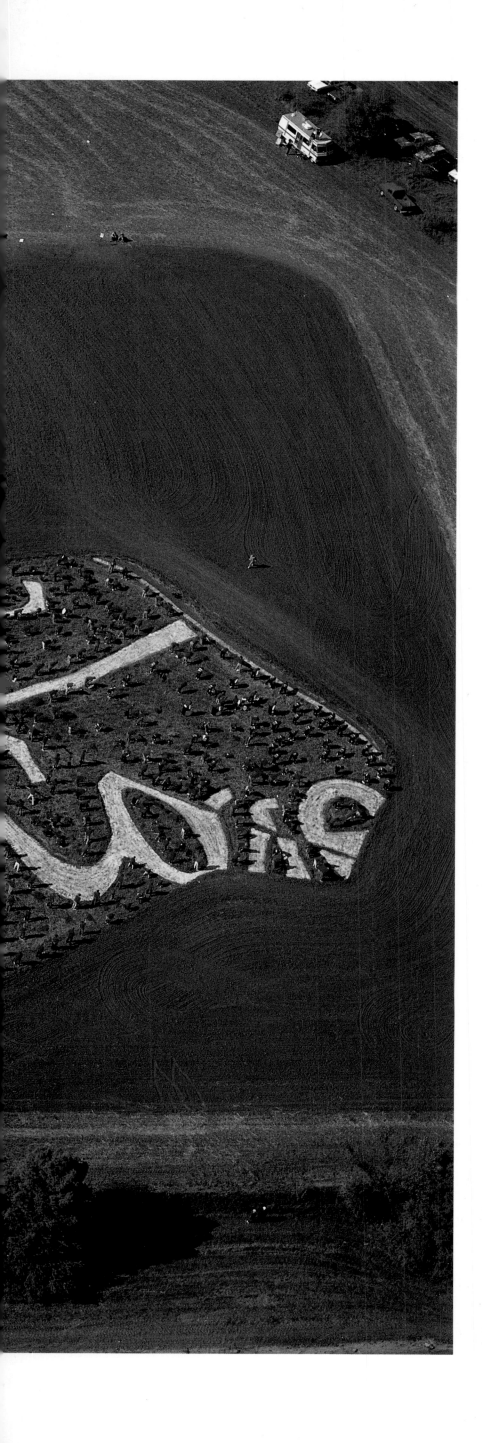

Commercial-ization and Artistic Survival

At 1,200 feet, set against the brown field and the white lime, the Pointillist dots of color worked to successfully embellish the *Ottawa Cola Wars* design.

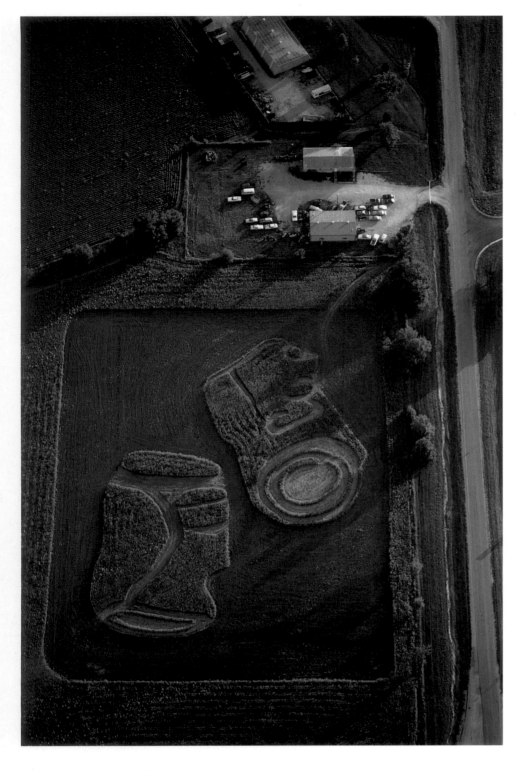

Early stages of the crushed cola cans situated on a five-acre soybean field near Ottawa, Kansas—each can is two hundred feet long.

THE OTTAWA COLA WARS

Those who have taught and inspired me inevitably are part of my work and my life. Sometimes I have to make a concentrated effort not to take either my work or my life too seriously. I like the observation by Ad Reinhardt that "an artist who dedicates his life to his art or his art to his life, burdens his art with his life and his life with his art."[5] I seek to keep those burdens—"taking things too seriously"—manageable. When they fly out of control, some humbling experience invariably acts to bring things once again into a balance.

The necessity to give back to those who have devoted their years and lives to my dream came into sharp focus in the summer of 1987. I had attempted to take a stand against involving myself in the production of large earthworks for "unsavory" commercial purposes and soon found myself in a most uncomfortable situation. Financial imperatives were about to force me to eat my words and compromise those ambiguous ideals. When self-imposed, humility probably is a less painful medicine, but I missed that opportunity. For me it was to be externally imposed, coming in small doses at first, in larger ones later.

McCann-Erickson, a major West Coast advertising agency eager to contract for my tractor skills, was pursuing me to etch out a logo for a giant Japanese/American corporation, looking for a unique way to present a new agricultural product. At this same time I was deeply involved in an art project twenty miles away in neighboring Ottawa, Kansas. That project, the *Cola Wars* field, grew from an Ottawa Arts Council request for me to participate in a two-week "artist in residence" program to help celebrate the council's tenth anniversary. Deborah Barker, council president, had envisioned an activity that could reach the whole community but more specifically involve students from area schools.

In part to force myself away from the enticement of commercial applications being proposed for my earthworks, I committed myself to an image that was not only noncommercial, but anticommercial, both in concept and in message. To this purpose, I mowed and plowed a sketch of two crushed cola cans into a five-acre soybean field, accented by graphic applications of lime (a natural crushed stone material). The image was very graphic and was defined by the contrast between plowed ground and the standing soybean plants, which made up the cans. The bean plant matures rather thick and green, when the plant has all of its leaves, but as the beans form in the pod, the leaves vacate the plant and the sparse remaining stalk turns a rusty brown color, as the photographs reveal.

The purpose of a side-by-side juxtaposition of the competing cola giants Coke and Pepsi was to symbolically cancel each other out and, in the process, perhaps raise an awareness in participating students about the way advertising shapes our culture. In my mind, the battle between the soft-drink behemoths provided the most visible example of the lengths to which corporations will go to secure product allegiance. The cans were crushed to bring attention to the fact that residue of our consumption ends up in landfills or strewn along our highways. Dan Dancer convinced a recycler to bring a truck to the event to visually reference the need for recycling as a further part of the message.

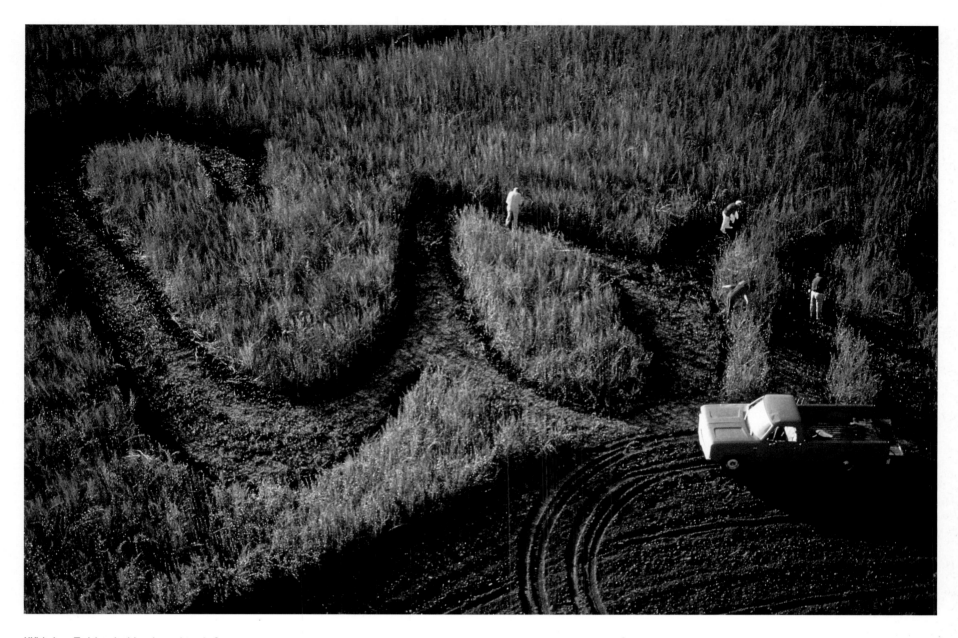

With her T-shirt-clad back to the air for more exposure, the artist's wife poses to measure the effectiveness of color dots from three hundred feet as the landowners assist in preparation.

After reading a number of books and articles detailing the history of a fifty-year (mutually beneficial) battle between these two manufacturers, I also wanted to address the role of artists in the present-day corporate equation. The efforts aimed at one-upmanship, by ad agencies for Pepsi and Coke, were making headlines nationally and internationally, highlighted by detailed stories of executives attempting to secure top performing artists of the day to promote their particular brand. There seemed to be a feeding frenzy to determine who could spend the most money. One superstar had recently received $11 million to "hawk" Pepsi. Major news media carried the story coast to coast.

Ottawa's two-week artist-in-residence program somehow quietly grew into a summer-long endeavor culminating in a one-day assembly of 850 color-bedecked participants who "artfully" positioned themselves under an aerial media circus jockeying for position overhead. As noted, the work was directed particularly at young people, the main target group in the cola advertisers' strug-gle for product allegiance. It is an inescapable paradox that my art piece probably gave both soft drink manufacturers a promotional boost, as do pictures of the project reproduced here.

Humility in a large dose came two months into the Ottawa project. I had initially turned down the West Coast agency's request with an explanatory letter emphasizing my "steadfast"

decision not to lend my services to corporations promoting eco-logically questionable products. (For those interested in the issues of giant chemical agribusiness's effect on long-term agriculture, I would suggest Jackson's *Altars of Unhewn Stone*, North Point Press., However, a series of financial reverses exacerbated by pres-sures from mounting costs of two underfunded field images cur-rently in process (a portrait of Saginaw Grant was the other) made me reconsider my position. After talks with Janis and a soul-search-ing call to the Land Institute in Salina regarding my financial/eco-logical dilemma, I became disabused of the idea that I would lose my integrity as an activist by accepting the means to a livelihood. Wes Jackson explained that survival of the Land Institute demands they take money from all who offer it, ending the conversation by saying, "Stan, all money is tainted and there 'taint' enough of it."

The following week I yielded to financial demands and accepted the project being offered by the ad agency. From that point on, I resigned myself to the fact of a necessity for capital in the pursuit of life and art.

October 22, 1988, was the day of the great *Cola Wars* "happening." It broke crisp and clear, not a cloud in the sky. At noon, one hour before participants were to converge on the soy-bean field farmed by Lawrence Lundstead, a rogue cloud forma-tion appeared out of the southwest, and those who arrived early

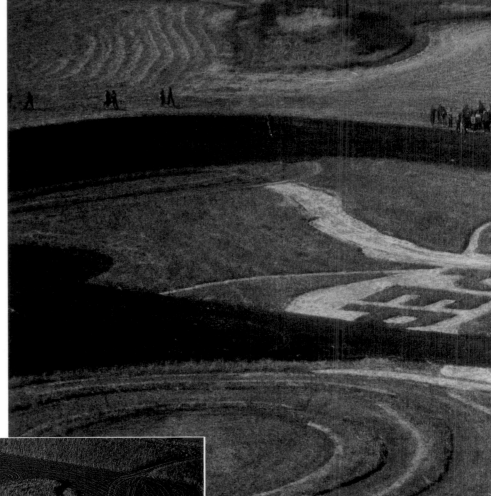

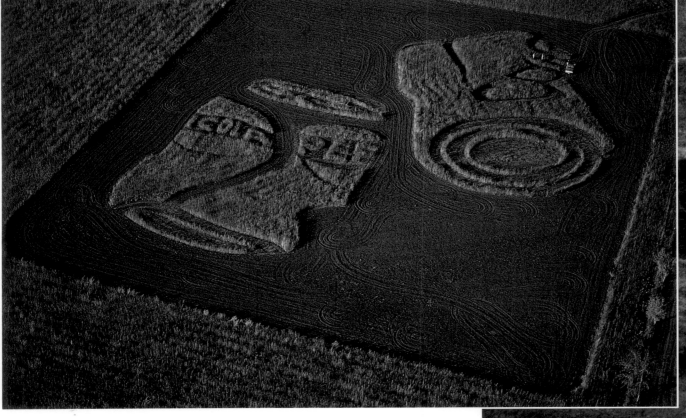

Above: The pop art image takes on the appearance of a sculpted rug as the soybean plants transform into rusty hues.

Top: Photographer Dan Dancer and his wife, Christine, pitch in to help spread lime, a natural crushed stone, to help highlight the graphic design.

Right: Close to nine hundred color-bedecked participants gather on the edge of the field behind team leaders, cued for entry to designated areas.

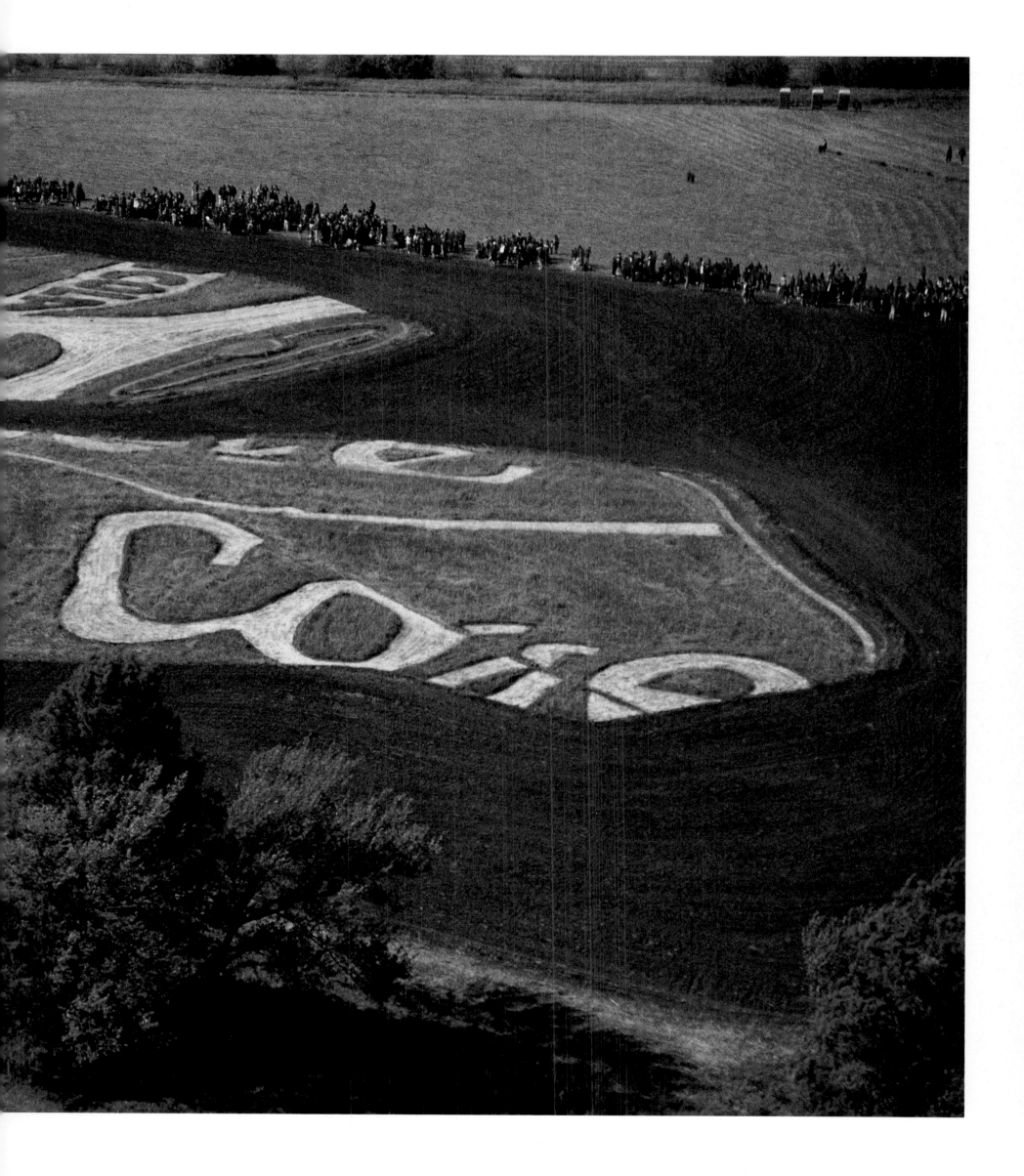

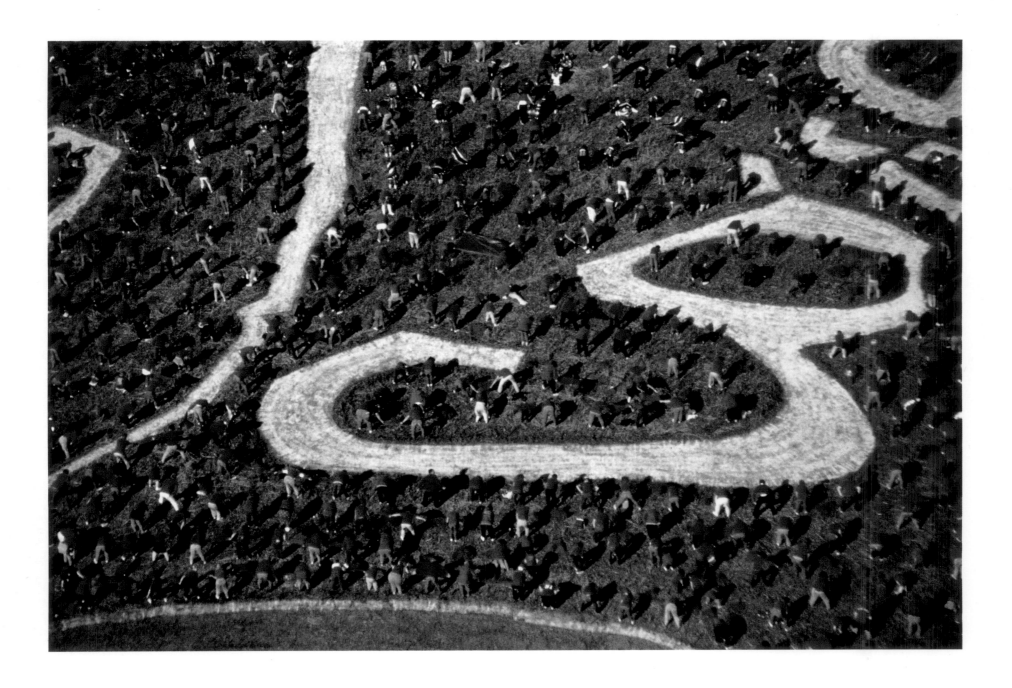

Participants included a high school band, a
man in a wheelchair, and two dogs, as well
as friends and relatives of the artist.

were pelted with rain—but for just ten minutes. When the sun
broke out to stay, close to one thousand people had arrived ready
to become points of color. They went to the task of forming lines
behind our dozen squad leaders who, on command, would lead
the participants onto the field. Details had been worked out days
in advance, and everything went without a hitch. Babies and
grandmothers, cowboys and bankers, two T-shirt–clad dogs, a
man in a wheelchair, two folks on crutches, and a high school
band, among others, came to make their point.

Good Morning America, scheduled to report the event,
discovered the previous day that their Texas network affiliate had
recently aired a short piece on my work, so they decided to drop
their coverage of the Cola Wars at the last minute. Nevertheless,
at one time three news helicopters and four airplanes were cir-
cling the field seeking an unimpeded view.

Three television stations from Kansas City, two from
Topeka, radio stations, and local newspapers joined in seeking
angles for their stories. It seemed everyone was trying to interview
everyone else. The wandering Alfred Packer Band alternated with
the Ottawa high school band to entertain the crowd as I and the
two dogs barked signals—mine through a microphone mounted
forty feet up in a lift-truck overlooking the field. Participants would
bend at the waist on specific signals in order to display their
T-shirted backs in such a way as to reveal the largest possible area
of color.

On special command, cola warriors bend to the task, performing as dots of color for the completed image.

A young participant sports a commemorative *Cola Wars* T-shirt designed and offered for sale to raise money to defray costs of the event.

It was over in only three hours. We had survived weeks of intense preparation, not to mention the great "Cola War" itself. Because of the unpredictability of autumn weather in Kansas and the logistics of a thousand bodies on a bean field, the potential for disaster had been grand. Totally exhausted, I silently resolved not to involve myself in "art happenings" in the future.

By this time I had already decided to pursue additional images evidencing stylistic approaches relating to the Post-Impressionists. Though the *Sunflower* image reflected little more than a subject matter comparison to Van Gogh, I had considered Cézanne's work, as stated above, in designing and executing *The Harvest* earthwork. Although at first this was not a committed direction, I grew to like the idea of designing successive images incorporating a stylistic principle introduced by leaders of Post-Impressionism. I would have to abandon that concept as circumstances pushed me toward a new portrait of a contemporary Native American, Saginaw Grant, but the *Ottawa Cola Wars* design was in fact already leading me away from such considerations—unless you see the pointillist dots of temporary color as a wink at Seurat.

SAGINAW GRANT

In May of 1988 I had photographed dancers at the Haskell University Spring Pow Wow and was particularly intrigued by the appearance of one man. After looking at the photographs the following week I realized that I wanted to attempt a portrait of this individual if I could obtain his name and secure his permission. I was successful in both endeavors.

After gaining his permission, I proceeded to carve and mow the image of Saginaw Grant into wheat stubble on a farm north of Lawrence. This was to be a first attempt to battle three projects in the same summer. The *Ottawa Cola Wars* project, which originally was to be the first to involve people in a final presentation of the image, had been in the planning stage for a few months. In a masterful piece of bad planning, I allowed both works to come to something of a media climax on the same weekend. The photographing of students on Saginaw's portrait, arranged by photographer Dan Dancer, took place on the day before the Ottawa media circus.

Saginaw is a very active man. I discovered after etching his portrait that he was an actor and was involved in affairs of concern to Indian people in general, and in matters of special importance to his tribe, the Sac and Fox. Currently involved with American Indian/Alaska Native Youth 2000, a program to instill pride of heritage in young Indian people, he appears in the United States and abroad as a contemporary spokesman for and about Indian issues.

At my invitation, Saginaw traveled from his home in Cushing, Oklahoma, to fly over and view his portrait. Manny King, student adviser at Haskell, came to participate with students from their Inter-tribal Council. Steve Cadue, tribal chairman of the Kickapoo, and his family also joined us and neighbors for a simple ceremony on the field.

The idea of returning to a portrait as subject matter for an earthwork had surfaced a number of times in my mind. I reflected

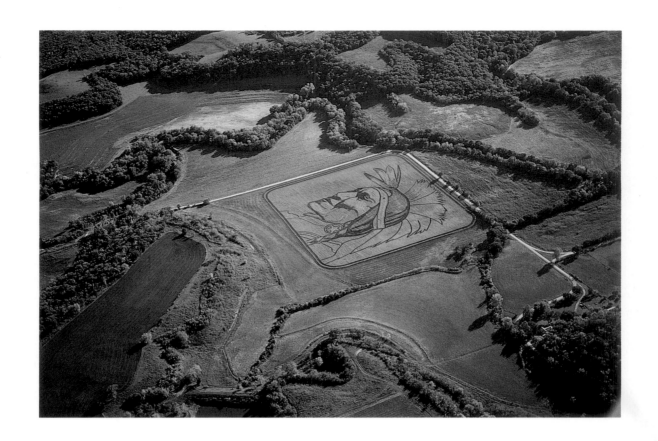

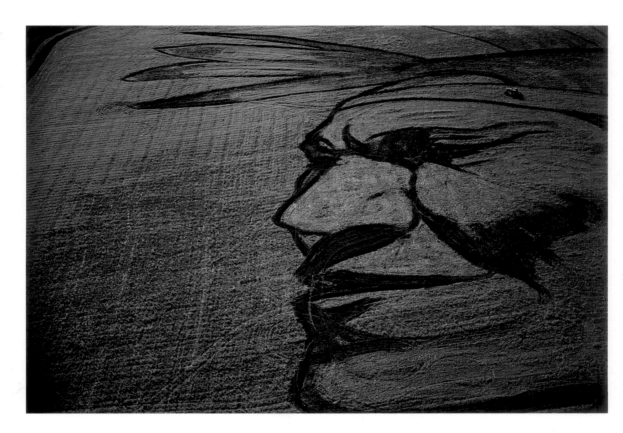

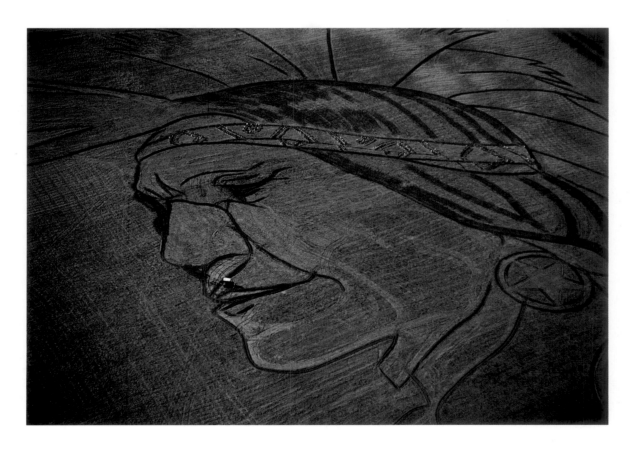

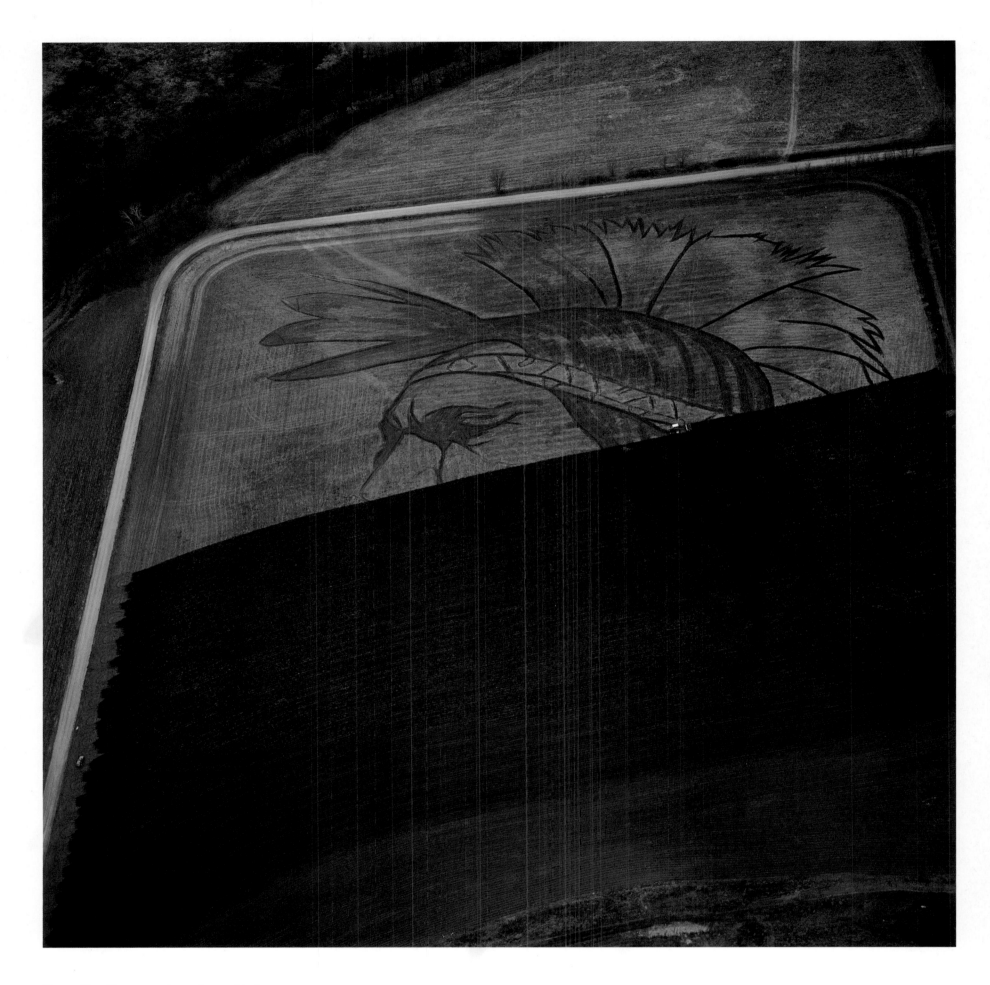

Above: Dan Dancer captures farmer Harlan Courtney returning the portrait to the earth—preparing the soil for winter.

Opposite, top: Situated in the big slough creek watershed, the portrait of Saginaw Grant, in a thirty-acre wheatfield, is surrounded by the small farms and trees of eastern Kansas.

Opposite, middle: From 250 feet the helicopter reveals the deep plow marks and the dark rich umber of the earth's pigment. Herd used a mower, a disc, and a two-bladed tractor "like different pencils" to give the image its complexity.

Opposite, bottom: Orchestrated by photographer Dancer, 450 schoolchildren perform as beads on the three hundred feet of headband.

Second

often on what might have happened with the two earlier portraits if I had been able to pursue them further. In the years since I last attempted a portrait, that of Will Rogers, my earthworks had become much more graphic, with large blocks of color set off by strong consistent borders. I had been contemplating the possibility of returning to a more representational style using subtractive methods (discing, mowing, plowing, and so forth) to achieve depth, shadow, tonal quality, and highlight, actually just to see what was possible.

Photographic documentation of the earliest works had been rather inadequate. While television had covered the works extensively, photographs of *Satanta* at its peak, save for a few I took myself, do not exist. Cotton Coulson's pictures of the *Will Rogers* image, which appeared in *National Geographic*, and Peter B. Kaplan's documentation of the same image were the only professional-quality photographs of either work.

In 1988, Dan Dancer had negotiated a contract with the Mid-America Arts Alliance to develop and promote an exhibit of his documentation of my work. Dan and the alliance had originally intended a balanced exhibit of all his photographs, mostly Kansas landscapes, but they eventually focused on my field works. I was not directly involved in those negotiations. At that time Dan had shot only two of my earthworks, the *Sunflower Still Life* and *The Harvest*, and was just beginning to document the Ottawa image. He suggested that if I would undertake another portrait before the exhibit, it could add important diversity to the show.

I hesitated to pursue this idea for a number of reasons, the most obvious being time and financial constraints. The painful ordeal in Lincoln was still fresh in my memory. With *The Harvest* locked in a second consecutive summer drought, and with increasing complications developing in connection with the underfinanced Ottawa project, the time and financing to pursue a new portrait were somewhere between scarce and nonexistent.

Seeking to address my very real reservations about time and money, Dan acted to alleviate both concerns. He personally shared in financing the project, located available fields close to his home, and found equipment for me to use in working up the image. Given that assistance my arguments and my resolve to be cautious about becoming overextended crumbled away. The twenty-four-acre field selected belonged to the family of one of his neighbors, Jack King, and was leased to a tenant farmer, Harlan Courtney, who was farming the ground without chemicals. For the first time I was not in direct communication with the landowner or farmer as I approached an earthwork. It made me uncomfortable.

In only a few weekends during that summer, I managed to etch out the outline and facial features of Saginaw Grant using mowing, plowing, and discing techniques. In Dan's photographs of the image from early summer to late fall, the separate mowing and carving treatments are recorded after each reworking.

Because the farmer needed to work his field before the first freeze, prospects for an early winter brought down the final curtain. By then I had hoped to do more with the earthwork, which I considered unfinished, but it had been consigned to the oblivion of the farmer's plow. Lessons learned in this endeavor were many, and for me, somewhat profound. The fact I was so overextended and struggling to battle three works on separate fronts assured my ability to control none of them. All this reinforced an earlier understanding—that my relationship to landowners and their lasting impression of the total experience was as essential to the work as the final image. For photographic purposes, Dan had invited students from a nearby Oskaloosa school to pose as beads on the design. I agreed to this somewhat reluctantly, as I didn't feel the image needed embellishments of that nature. I also had some concerns about how Indian people might react to the playfulness of the idea, although I did not mention that to Dan.

The issue of defining Dan's role in the overall works became a point of concern and eventually of contention. As he began to suggest ideas and to stage photo opportunities in the form of activities on and over the work including hot air balloons, animals, and people, he grew more inclined to think of the work as a joint creative effort. On the other hand, I was of the opinion that he was primarily documenting the process and the stages of *my* work. Many people, including farmers, friends, and especially my wife, are involved in the creative process, but my work issues from my upbringing and my experiences, so my thinking went and, more importantly, issues from earlier trials and struggles on the fields of western Kansas.

Eventually we worked out our differences. As evidenced by examples of his work in this book, Dan is a premier photographer and an artist in his own right. Indeed, he has gone on to pursue an artform of his own making. With environmental sculptures made from found items reflecting activities of humans and animals, his images have been set in geographic regions from Alaska to South America, and he currently has a traveling show of photographs of his eco-sculptures sponsored by the Mid-America Arts Alliance.

Alluded to above, the issue of non-Indian artists depicting Native Americans in a stereotypical presentation later grew in importance during conversations with friends after the work was plowed under. I had always tried to be sensitive to that issue, and to veer away from any possible exploitation of Indians in my work. As I began to grasp the significance of that situation in the earlier seventies, I had stopped portraying Indian people on my canvases, at least those that were for sale to the public.

I do hope most Indian people see my work as an attempt to honor them. Some may not. In the light of present knowledge, I probably would not choose to pursue the portrait of Saginaw, even though many people tell me it is my most successful work, the image they like best.

VODKA AND AUTOMOBILES

In the early years, when I wasn't receiving money to do earthworks and had scant resources with which to encourage the involvement of others, life was simpler. Those who got involved did so more for adventure and challenge. They were intrigued by my determination. On later projects, when corporate or city funds were involved, some landowners became leery, and our relationship, of necessity, became more business-oriented.

I have been warned by confidants not to delve into the

quagmire of the relationship of artists to the corporate system, but it would be impossible to leave it out of any serious discussion of either my work or my understanding of dilemmas faced by modern artists. The contemporary artist's relationship to faceless corporations is a continuation of the story of the influence of patrons on art. I believe that relationship to be as relevant, art historically speaking, as past relationships between the artist and the king, pope, emperor, or families of great wealth.

Since my works attempt to embrace rural sensitivities and issues of the land, I have become the recipient of much attention from advertising agencies representing major national and international agricultural conglomerates, some looking for ways to shore up their image in the face of evidence of massive problems relating to modern agriculture as it is currently practiced. With groundwater contamination resulting from aggressive use of chemicals, topsoil loss resulting from the modern plow, and increased dependency on fossil fuels to move giant machinery, modern agriculture, as currently practiced, is under intense scrutiny.

In recent years I have walked away from some commercial projects that did not fit my floating parameters while accepting those that have challenged me artistically or set better with my conscience. The financial success of these latter commercial endeavors has given me stability and an opportunity to pursue "pure" or "fine art" artworks with much less compromise. It is still

Golden wheat falls to the combine in a test cut along the edge of the bottle, July 1989.

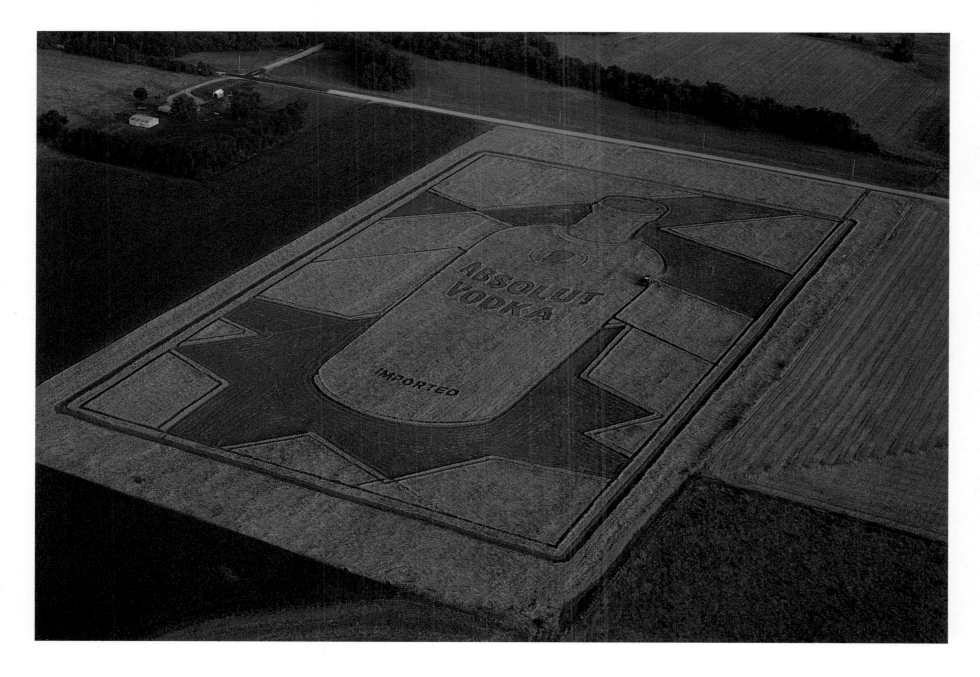

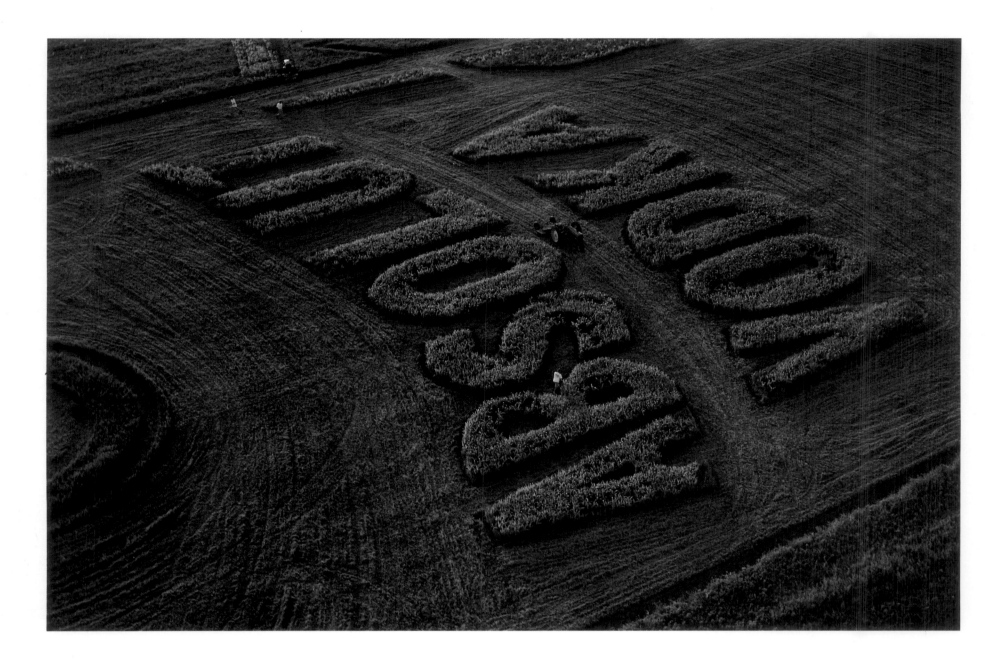

Above: The artist, along with assistants,
tends to giant sorghum-plant letters
growing on a background of mowed clover.

Right: Early stages of *Absolut Landmark* cut
out of green wheat in late May 1989.

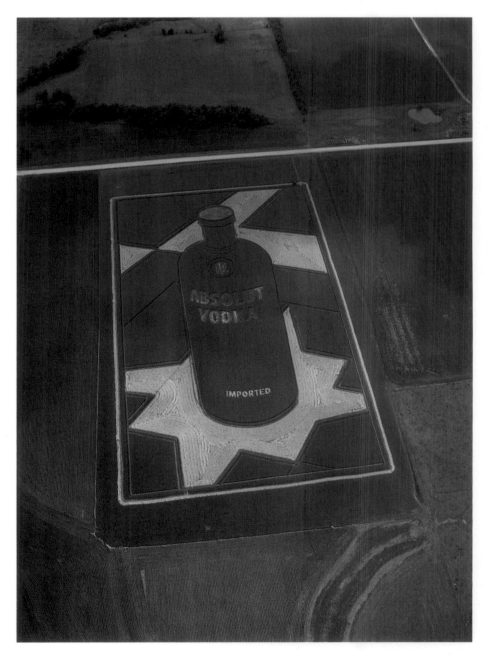

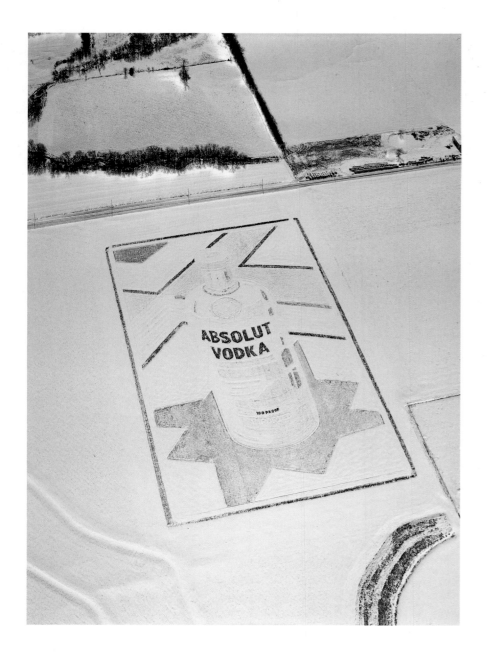
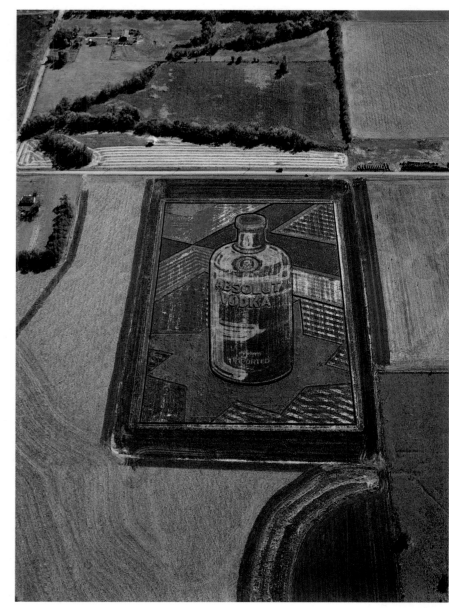

Above, left and right, and overleaf:
Absolut winter

somewhat disconcerting for me, as the son of people who have struggled financially all their life, to turn down significant sums of money because of an ideal. In times of weakness, I think of it as a silly and irresponsible thing to do, especially given that Janis and I have the responsibility of providing for a young son. In times of perceived strength I understand that an adherence to ideals is what defines me as an artist and as a human being.

As stated earlier, the *Cola Wars* field was directed mainly to young people. There is something a little predatory, I believe, in manipulating adolescents, not just to buy a product but to bend their image of that product in such a way as to form an allegiance to its consumption, whether footwear, tobacco, or soft drinks. It is a trend out of control. For example, it seems incredible but is nonetheless true that American young people in major cities have killed their peers over jackets of professional athletic teams.

A later decision to lend my earthworks to adult products such as vodka and automobiles pushed my credibility on this issue to a tightrope walk. It has been said that Andy Warhol eliminated the distinction between the avant-garde artist and the general public; between the commercial graphic world and the world of fine art. If it begs the question, I suppose I would answer critics by stating that I am not a celebrity and it seems unlikely anyone is

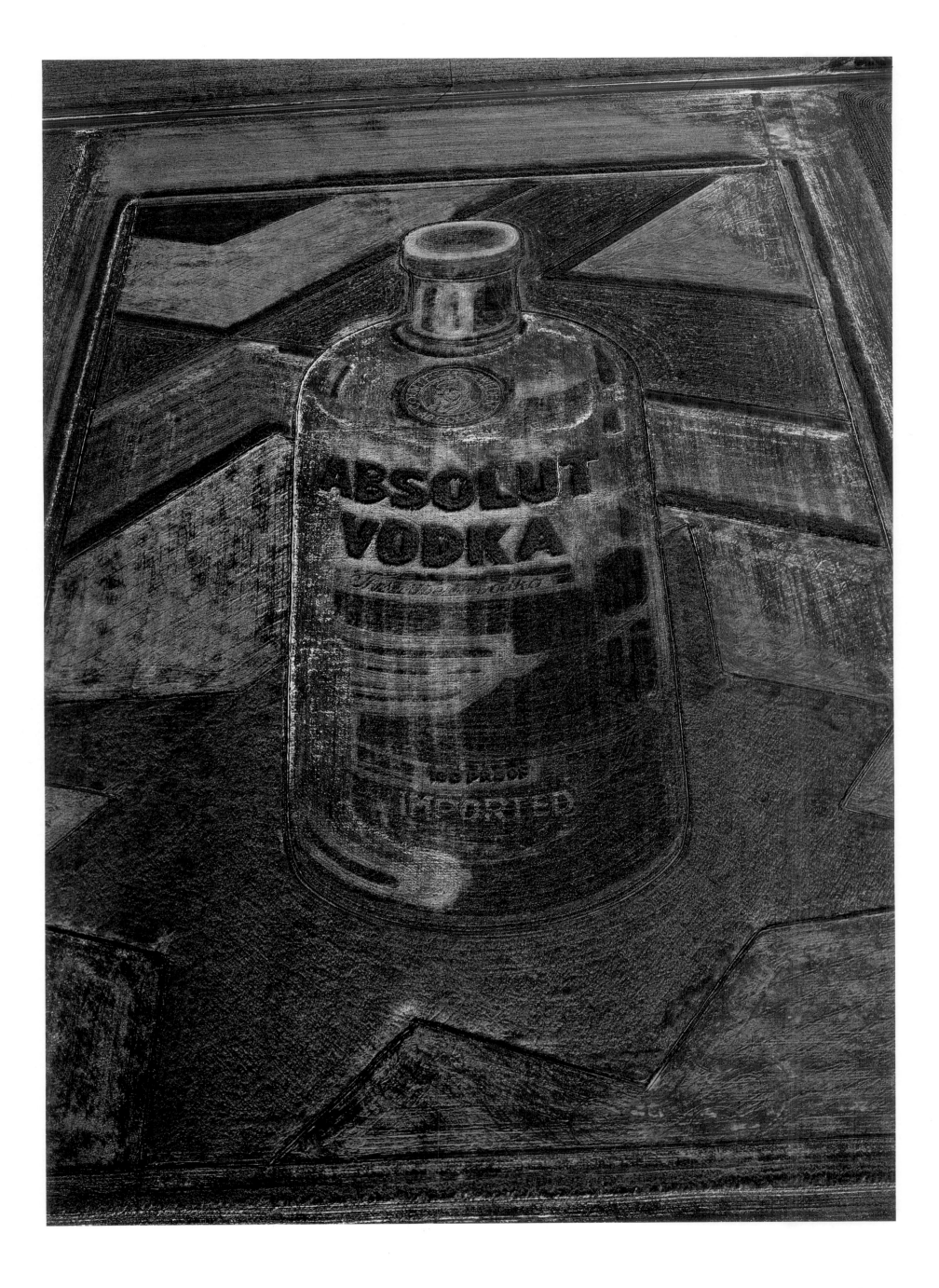

going to buy Absolut vodka or a Buick specifically because Stan Herd gave his workmanship or his name to promotion of the product. Still, I remain somewhat chastened by the fact that I have been "backsliding" on the message I was sending to young people with *Cola Wars*.

I do still believe the modern artist has a responsibility to maintain a position of objectivity outside the system of commerce. The catch-22 is that the hungry artist looking for a way to survive often finds it necessary to pursue the marketplace of the art world, the marketplace of the corporate world, or government grants. I am fascinated that the role of the artist in contemporary society seems to be as vague now as it has been throughout history. Ask ten people what the artist's role is and you probably will get ten disparate answers. Few people are likely to view the artist's role precisely as I do. And my own view is still evolving.

Absolut

As financial considerations continued to inhibit my desire to pursue earthworks of my own, the need to capitalize on my abilities convinced me look for the right patron, one who would allow artistic license and also reward my efforts. After looking over the field of advertisers to see who was doing something unique, it came to my attention that TBWA Advertising, Inc., in New York was utilizing an aerial perspective in a number of ads featuring Absolut vodka for Carillon Importers, Ltd., in Teaneck, New Jersey. "Absolut Manhattan" was an advertisement depicting an elevated view of Manhattan Island, with Central Park manipulated to appear in the image as a giant bottle. "Absolut 19th" was a similar treatment incorporating the bottle into a golf course green. Both images were created on studio drawing boards. I also began to take note of the Absolut Artist series, which personalized the advertising approach to give individual artists a platform for personal expression. Although most of the images included in the Artist series spotlighted the bottle in the context of an artist's particular style of painting or design, in some of the works the stylistic approach overwhelmed the product item, and I was impressed by the freedom given to artists in the campaign. The campaign was winning awards and shaking up the highly competitive advertising world.

For the first time in my life I called an advertising agency to solicit work. Andrew Judson of TBWA invited me to send photographs of my work to their New York offices, and within a month I was in the office of their client, Carillon Importers, to meet with Michel Roux, president and CEO. I was forewarned that Michel was a man prone to making quick decisions. He did not disappoint. After agreeing upon how we would proceed with the earthwork, Michel and I quickly discovered a shared interest—Native Americans. Michel had been involved with Indian issues for a number of years and was especially active with the Iroquois in upstate New York. Through the Grand Marnier Foundation he was supporting the Iroquois lacrosse team in international competition. During the initial stages of implementation of *Absolut Landmark*, I was honored to receive from Michel an invitation to the Onandaga Nation to meet their chief, Oren Lyons, and Leon Shenendoah, chief of chiefs of the Iroquois Nation.

What I had failed to understand at the time of my arrival in New York that winter was the nature of the seduction that this art/corporate approach had had on the art community as a whole. I heard one story, which emphasizes the point, about an artist who had haughtily turned down the request to get involved with the series, only to pursue the project vigorously the following year when he saw how successful the series was. His effort in pursuit went for naught.

Artists were flocking to Carillon's doors in droves. So much for the independent, heroic, and unfettered artist. Michel had a staff that did nothing but look through that day's shipment of Absolut *objets d'art*. I believe Michel and the creative team at TBWA were becoming a little embarrassed about the eagerness with which the art community was pursuing them.

For the first time in my pursuit of an earthwork I had ample funds to create and to experiment, even though that creativity was confined by the necessity to include a definitive item or product, the bottle. Working again with the Neis family, we decided to "double-crop" the eighteen-acre field, planting both clover and wheat at the same time. The wheat would mature first the following spring, and I would use that crop to etch out the initial image. Once the wheat was harvested in late June, the dormant clover, which was hidden from the sun by the dominant wheat, would begin to flourish and establish itself for further image manipulation. Clover, a perennial hay-crop, is cut and baled four or fives times during a season for livestock consumption. Its most appealing quality as it relates to my earthworks is that because of its sturdy nature, similar to lawn grass, I can drive across it to enter areas of the design without destroying the crop or the image.

I decided to render a fairly straight-on view of the bottle, and in keeping with the earlier still lifes, situate the object on a quilted table top with a slightly elevated view. The star quilt pattern providing background for the bottle was of my own design. The image began to take shape in a very graphic form in early summer with the help of abundant rains, which gave us lush wheat and thick clover. Photographer Jon Blumb began documentation of the work after being awarded a contract to shoot the advertisement. The image changed dramatically as the wheat turned golden. As we followed the wheat harvest with a second planting, we realized the client might have many individual stages of the still life to choose from. Leaving the wheat stubble in some areas for color and texture, remaining parts of the image were either dominated by clover or planted to milo or soybeans, all with the intent of realizing a colorful fall image. Students from Kansas University's Art and Design programs assisted me in implementation of the design.

Earlier, in the fall of 1990, more than six hundred people showed up at the field for an all-day barbecue, drinkout, and fly-over, sponsored by the neighboring Absolut distributorship. With two small helicopters departing every four minutes, everyone who had the inclination got a one-thousand-foot view of the "work in progress." Under a large tent, with a jazz band providing background for the aerial festivities, the ebullient crowd devoured a hog on a spit, washed down with forty gallons of spirits, and the day miraculously went off without a hitch.

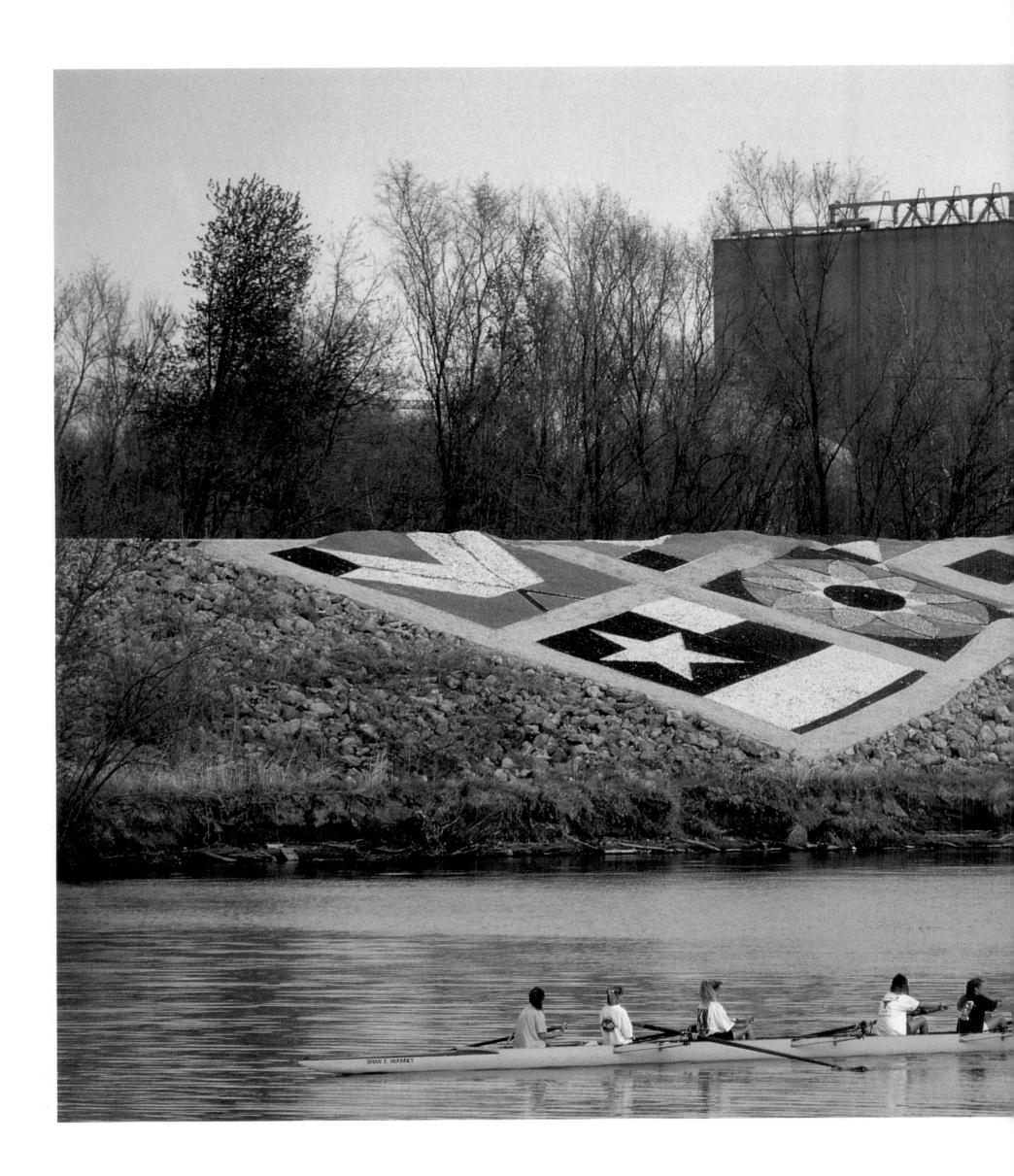

last for the riverbank and building to a height sufficient to protect the city from flood.

More than two hundred man-hours went into the artwork. With the help of numerous business groups and many generous individuals who donated materials, equipment, and labor, we began the image-creation process in late spring of 1989. For one full day, dump trucks continuously unloaded 150 tons of limestone fill (a fine-grained material which sets up almost like cement when wet). This became the "canvas" on which I then strategically applied colorful stones, rocks, and gravel to form the graphic patterns which made up the quilt design. My intention was to make it appear as though a quilt had been casually thrown over the side of the levee, with one area designed, in a trompe l'oeil effect, to appear as a fold.

The final image included four complete squares. One contained a view of the fiftieth star, a close-up of the corner star adjacent to stripes, which suggested the American flag. A second square depicted the Sunflower quilt pattern, which, as the state flower, represented the state of Kansas. The King's Crown quilt pattern symbolized our independence from the Crown of England, and my own design of two graphic eagle feathers represented indigenous people.

Children playing on its surface gradually blurred the edges of lines by scattering stones and gravel into adjacent areas. The resulting effect was interesting, but not in keeping with that which had been intended. After two years or so the image was fully erased.

THE SPENCER MUSEUM QUILT

On the occasion of its tenth anniversary, the Helen Foresman Spencer Museum of Art on the campus of the University of Kansas commissioned me to design an image for a small plot between the walkways at the museum entrance. With the help and guidance of museum photographer Jon Blumb, exhibit designer Mark Roeyer, and interim director Doug Tilghman, I eventually proposed a quilt design incorporating crops, wildflowers, and stone. *Worked Patch* was specifically designed, in keeping with the aerial viewing concept of my earlier earthworks, to be seen from an upper floor viewing area in the university's Student Union building, which is sited at a much higher elevation directly across the street from the museum's entrance.

After years of studying my completed works in photographs that focused on the total image, I became intrigued by those that zoomed in on small sections, which revealed texture, pattern, and color outside the context of the full image. Jon Blumb and Dan Dancer had already begun to shoot interesting designs and anomalies within the larger image, and I often offered suggestions and encouraged them to that end. The idea of *Worked Patch* grew from those considerations.

Using the Student Union landing overlooking the site as the viewing point, the design would be seen as a "revealed section" of a supposedly hidden larger pattern beneath the surrounding walkways. The perspective of the pattern was intended to fall away from the viewer and distort from any viewpoint other than that "sweetpoint." At that point the image "reads" in proper perspective. The design was somewhat successful in fulfilling my

intentions of producing a viewpoint that was slightly disconcerting when observed at ground level. Color, texture, and evolving planted material obviously commanded the viewer's attention at that level.

In the context of my other earthworks, this piece is like a printmaker's miniature. The site, measuring eleven by thirty feet, was stripped of existing gamma grass and the soil reinvigorated by the addition of new topsoil and natural additives. Janis, who has a much better grasp of gardening and landscape issues, guided the initial plant installations. Our original intent to plant native perennials (flowers and grasses) was frustrated by problems inherent in establishing indigenous plants. We wanted to have a strong image by the anniversary celebration, but wildflowers and plants usually take a complete season to mature fully and then bloom the following year. Eventually we settled for domestic flowers and agricultural grain plants typical of the area.

The University of Kansas, with a strong mix of international students along with students from every geographic region of the United States, is surrounded by farming and agriculture-related industries, yet it does not have an agriculture program or department. The state legislature assigned that function to Kansas State University some 120 miles to the west. Thinking many Kansas students probably might be lacking in an understanding of how the region's economic stability was dependent on grain, I hoped it might be informative to display some of these crops on campus. I also thought art history students frequenting the building might enjoy watching plants mature from sprouts to large heads of grain. What I didn't count on were rabbits and birds. Wildlife of every kind found the art so attractive as to be irresistible. My hope for a harvest of grain-laden heads fell to the feast.

Worked Patch, consisting of Kansas wheat and domestic flowers, along with stone and wood, situated in front of the Helen Foresmen Spencer Museum of Art at the University of Kansas.

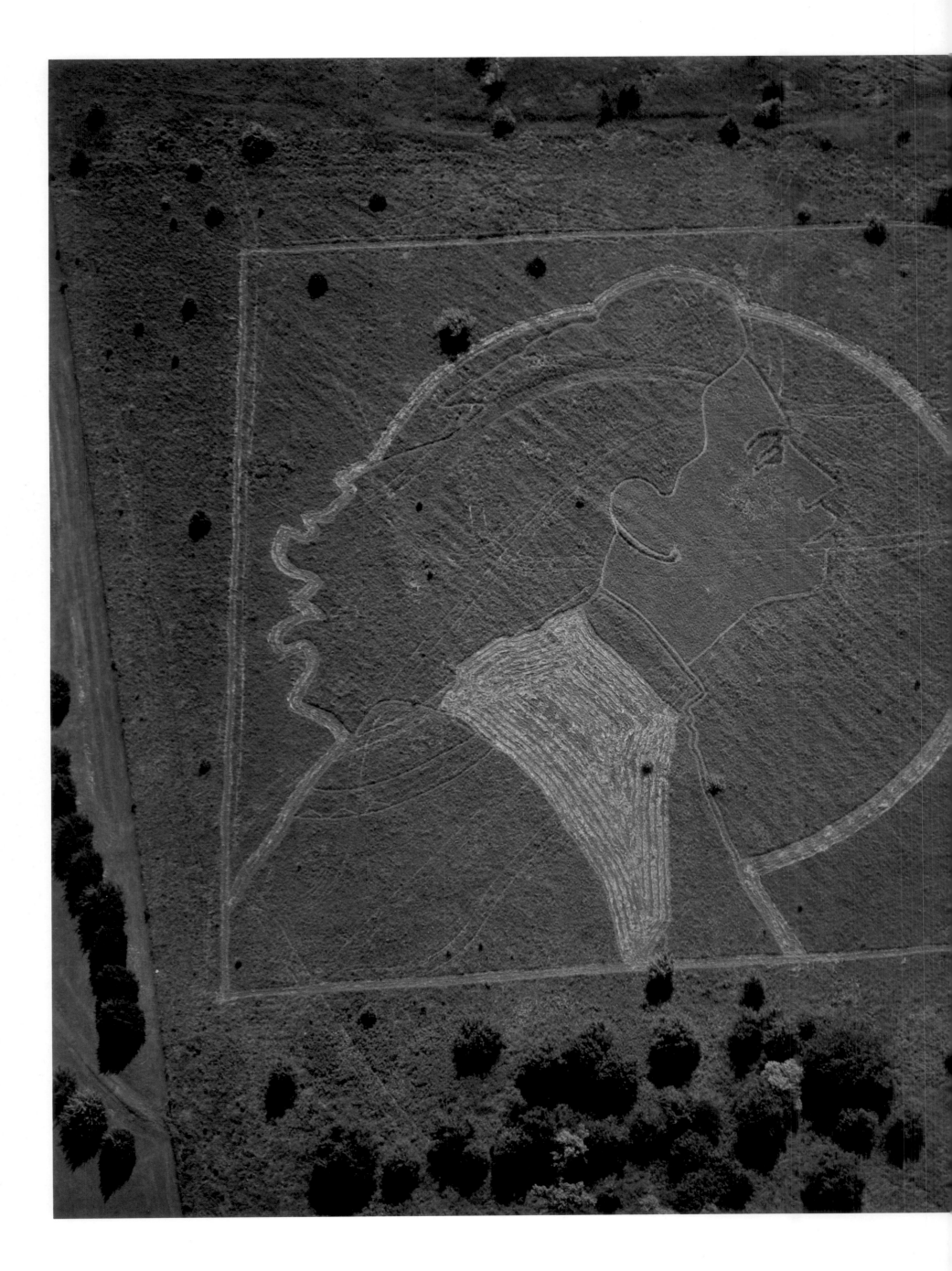

Current Works

Sitting on four acres of prairie near Salina,
Kansas, *Little Girl in the Wind* is the artist's
first earthwork defined without plowing the
ground.

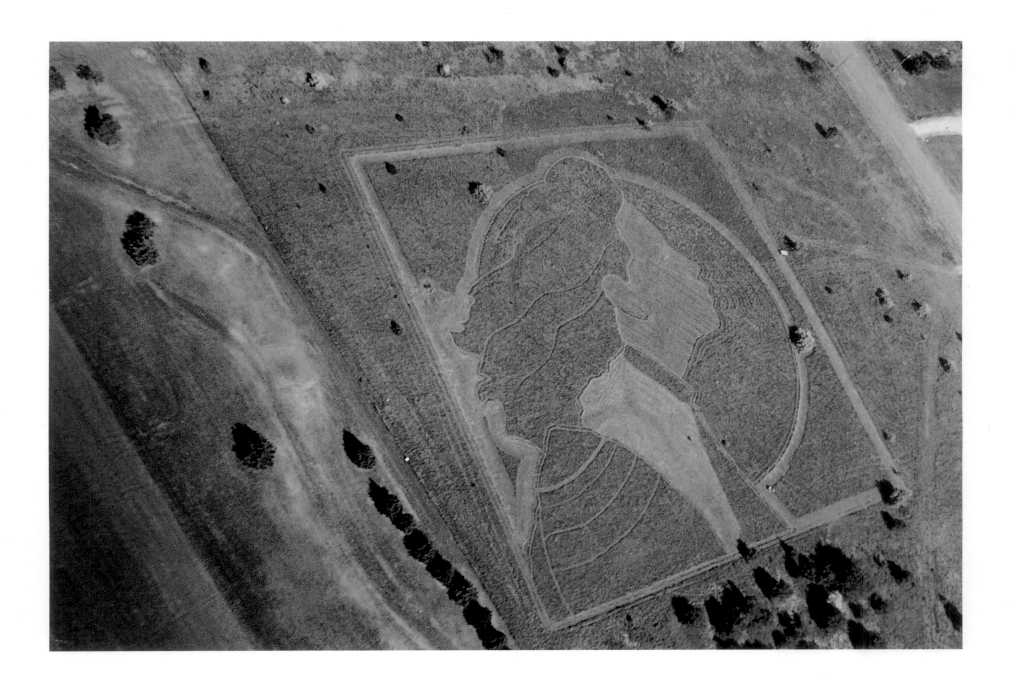

Little Girl in the Wind is the artist's first in a planned series of portraits of indigenous women in their homelands. The subject, Carole Cadue, is a Kansas Kickapoo.

LITTLE GIRL IN THE WIND

A trip to Costa Rica in 1989 came as close to a spiritual experience as any other act in my life. In my twenties I had adopted an idea that an artist should step outside comfortable and known boundaries to develop a more global viewpoint. Until 1989, in terms of foreign travel, I had not done so. In my view, it is necessary for an artist to be both a citizen of the world and a citizen of his own country. As have so many before me, I was finally to see my country and that greater world from foreign soil, to witness firsthand another culture, another people.

The little I knew of Central America had been gleaned from reading a number of books on United States involvement in the affairs of countries in the region dating back to before the time of Theodore Roosevelt and the Panama Canal. That involvement obviously had continued; in 1989 the United States was attempting to overthrow the government of Nicaragua, the country sharing Costa Rica's northern border.

Then two weeks before departure, I happened to view a film on the country of Costa Rica entitled *La niña e el viento*, translated as *The Little Girl in the Wind*, a documentary with a title based on a woodblock print by renowned Costa Rican artist Francisco Amaghetti. The print depicted a frightened child standing in the winds of worldly affairs, represented by graphic male figures

whose breath seems to cause the turbulence referenced in the title. With the help of the U.S. Embassy in San José, I made contact with Don Francisco, visited his studio, and began a dialogue which led to a conceptualization of a work currently in progress. I have envisioned this field art piece as the first of an undetermined number to be titled the *Nation's Portrait Series*.

The essence of the film was the portrayal of a delicate balance of the fragile democracy of Costa Rica caught in the winds of global and regional power struggles. Costa Rica is almost unique in the world in that many years ago it restricted military funding to the point that it effectively eliminated its army, and then applied those funds to fight illiteracy and minimize poverty. Costa Rica had essentially turned its back on the gamesmanship of world power brokers. And, from the documentary, I could see the whole story embodied in a single piece of art. I was impressed once again by the power of art and by its potential for influence. While the film producer's interpretation of Mr. Amaghetti's work may or may not reflect the artist's original intent, I have concluded that an artwork's influence on events and people can easily assume a life of its own with unintended or unexpected consequences.

My field images were being disseminated to a world audience through SIPA Press in Paris in the late eighties and early nineties. International interest naturally reinforced my earlier view that my earthworks should, if possible, speak to global issues. Interestingly, at that same time I was becoming aware of parallels between the history of American Indians and that of other indigenous people in many third-world nations. Throughout the third world, and in enclaves within some industrialized nations, aboriginal peoples continue their struggle to retain a cultural identity. An awareness of this led me to ponder whether a second parallel might exist between a technically advanced civilization's treatment of the environment and the way indigenous people are treated by that same incursive civilization.

The *Nation's Portrait Series* of young indigenous women in their ancestral homelands has seemed a natural new direction. The first image was already in mind as I returned home from Costa Rica. An important component in realizing this new direction was already in place. Martha Rhea, director of Arts and Humanities, in the central Kansas city of Salina, had contacted me back in the fall of 1988 suggesting I consider Salina for my next earthwork. Martha had helped fashion a very progressive atmosphere for the arts by organizing a private citizens' group known as "Horizons 50." Their mission was to provide private financing for art activities. I had delayed making a commitment to them while contemplating where I next wished to go with my work.

Meanwhile, needing time away from the fields, I occupied myself with mural commissions. Tempting calls to pursue commercial projects continued to increase in frequency. These had strengthened my determination to stay focused on art fields which issued from and in the service of ideas and ideals. The Salina image was to be my third commissioned earthwork, but happily, the first with no strings attached; I was given creative license and there were no time constraints.

From the initial contact with Salina, I had envisioned an image that might relate to the work of Wes Jackson and the Land Institute which, as noted earlier, is located near there. I hoped this earthwork might connect philosophically and, maybe even in its physical application, mirror the research going on there.

An invitation to talk about my work at the annual spring festival held on the grounds of the institute's farm in 1987 had somewhat redirected my energies to issues of modern agriculture and agribusiness. At that time I began to harbor a desire to work with the "Land," as it is known in Kansas, and hoped that the very process would enable me to better understand the issues and research going on there. I was not disappointed. Wes Jackson's philosophies and principles embody a global perspective and, not surprisingly, his struggle for credibility found voice in intellectual circles on the coasts, and internationally, long before he was accepted in his own backyard. Gregarious, animated, and stalking a crowd in search of intelligent discourse, he conveys an aura of excitement. I've come to think of him as a performance artist of sorts, with the world as his stage. I took to heart his comment, "We must be more mindful of the creation of the original materials of the universe, than of the artist's hand in creation." In his book *Altars of Unhewn Stone*, he states, "People must show greater respect to nature in its original form than to science," and, "The future of the human species on this planet will depend more on discovery than on invention."[6]

The interconnectedness of ancient and contemporary tribal people with Mother Earth at the center of their spirituality and life, represents to me the essence of what has been lost to modern man, obsessed by his need to control and manipulate nature. The *Portrait Series* issues from my view that, as presently constituted, the world sometimes seems a wonderful playground for those who are wealthy and a virtual hell-ground for the impoverished, especially young women of color who live in poor circumstances.

I had met and formed a friendship with Steve Cadue and his family a year or two earlier. We were introduced by Lance Burr, generally recognized to be Kansas's leading attorney on Indian issues. As tribal chairman of the Kansas Kickapoo, Steve and his wife, Karen, were involved in what they perceive to be an endless legal struggle to preserve Indian sovereignty. Concurrently, they were seeking a means to greater economic stability for their reservation in north central Kansas. After asking permission, first of the parents, I communicated my idea of the *Portrait Series* to their daughter Carole; she took to the idea with enthusiasm. After explaining to the Cadues the source of the proposed title *Little Girl in the Wind* I was startled to learn that Carole's given tribal clan name was Pah-e-Dahts-no-Qua, meaning "The first breath of wind from an impending storm." It would prove prophetic.

Carole, as subject for a first portrait in the proposed series, represents the United States. The Kickapoo story is representative and reflective of the history of many tribes in North America. They were pushed from their original home grounds in the lower Great Lakes region in the mid-1800's, and were given a large portion of land in Kansas. According to historians at the University of Kansas, that landholding subsequently dwindled to less than one-tenth its original size as non-Indian Kansans recognized and took steps to exploit the potential of the Indian land. The nature of those steps, which apparently included prejudicial legislative acts, have been well documented by historians.[4]

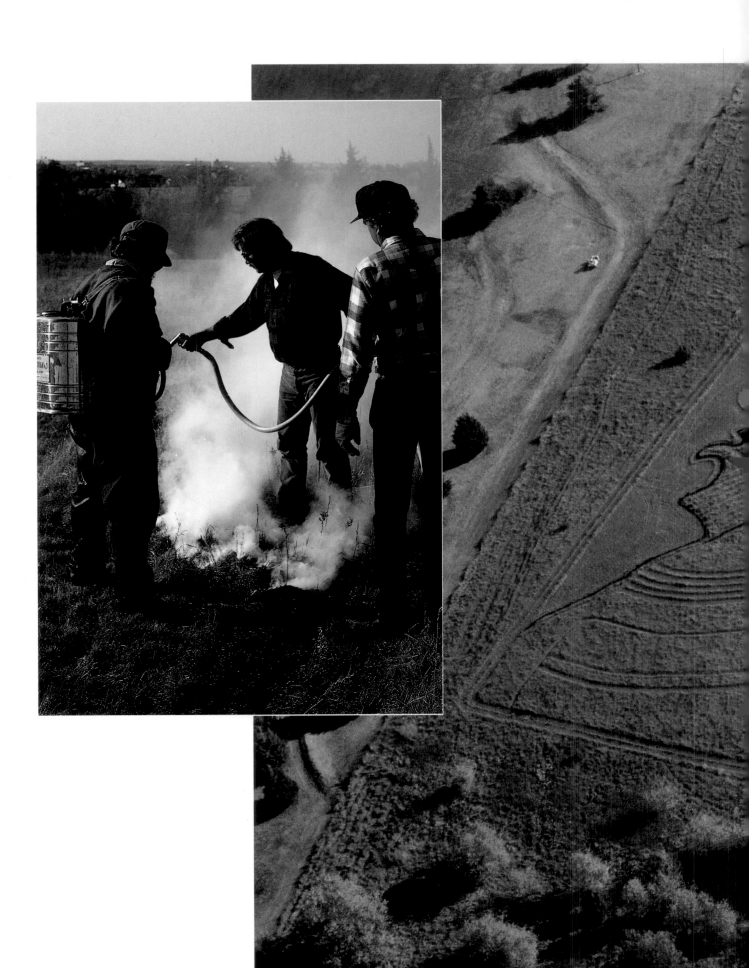

Above right: Burning to control the thick prairie thatch lends a temporary outline to the subtle image, fall of 1990.

Above left: The artist and assistants monitor the flames' path.

Left: Fire changes the diversity of species mix.

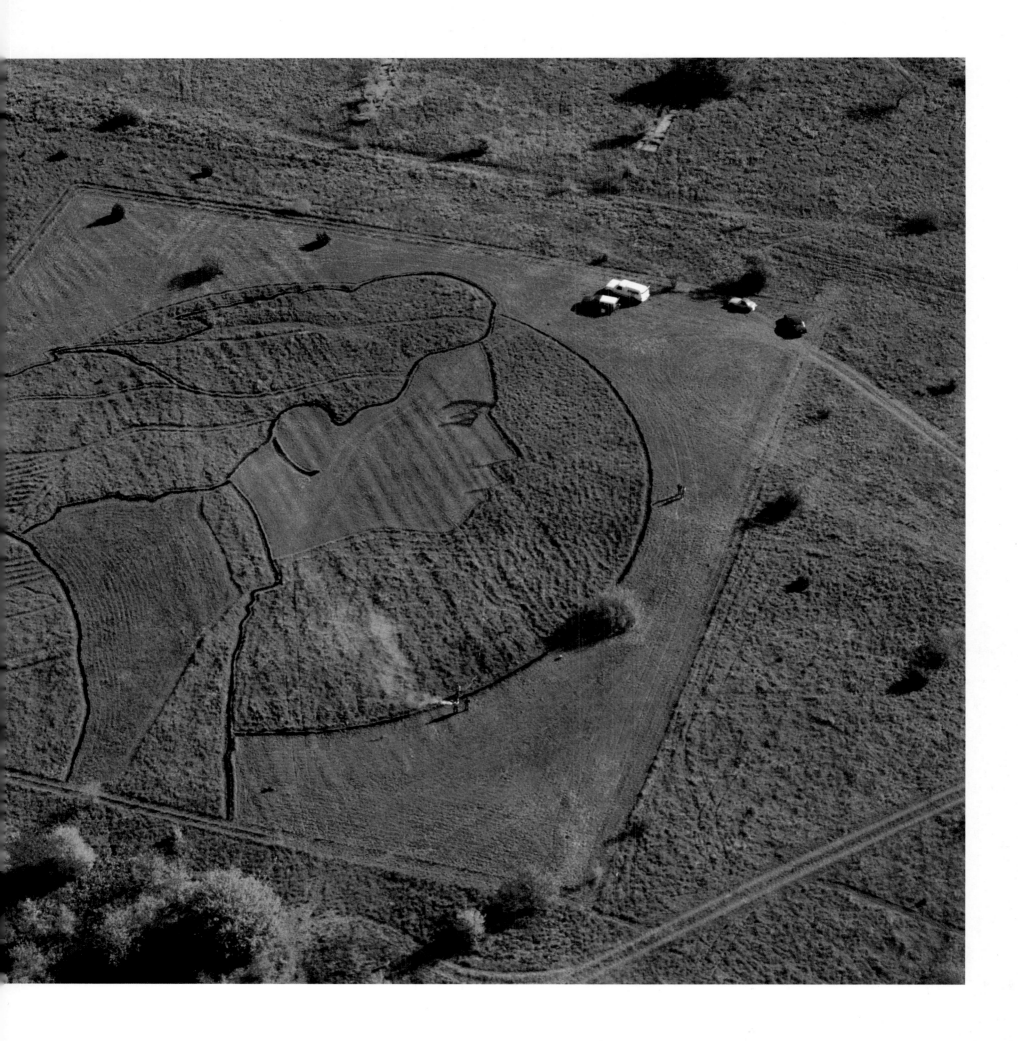

Implementation of a portrait of Carole into an unplowed prairie posed several new challenges. If my work was to address the issues of comparing pristine prairie to the fields of modern agriculture as embodied in the philosophy and research of the Jacksons, how could I etch an image into the prairie without ripping the sod and manipulating nature to artistic needs? After counseling with the staff at the Land it was decided I could use techniques of burning and mowing, prescribed for maintenance of natural prairies, augmented by site-specific hand plantings of indigenous plants.

I expect this field image to persist and evolve for many years. At some point in the future we will let nature regain control of the site and the success of my attempts to reestablish indigenous plants will be at the mercy of the soil and the seasons. The problems of manipulating nature to artistic needs came to a head with this work, my first attempt at "prairie art."

When I left the field to pick up another container of water the wind was blowing lightly from the south, as is common in spring and summer on the high plains of Kansas. (The Kansa Indians were named after that prevailing south wind from the Gulf, so, by its name, the state of Kansas identifies with that same phrase, "south wind.") I had departed with a suggestion to my helpers to put out the remaining tendrils of smoke, which we were carefully controlling as we sought to burn a twenty-inch trail

around the perimeter of Carole's portrait, which had been mown out the previous fall. A mile away at a water station, while securing the lid of the water container, I felt a cool blast of wind from the north, the first breath of wind from an impending storm front. As I looked back in the direction of the field I caught sight of a black cloud of smoke. Before I could get into my truck I heard the telltale honking horns of fire trucks. In the four minutes it took for me to return to the field the top portion of the image had exploded into flames, which were rushing south toward the fence line.

We had gained permission from the Salina fire chief to perform a controlled burn, and the weather report had not mentioned the possibility of heavy wind or other changes in the weather. It was all over in minutes. I had finally experienced the feeling my father must have felt when those hail storms destroyed a year's work in the teary blink of an eye. After a week spent lamenting my loss and wondering whether this should be seen as a project-ending disaster, I called the Cadue family. Their supportive words persuaded me to persevere.

In the fall of 1992 my helpers and I hand-planted 450 yellow coneflowers in the moon crescent behind the profile of the portrait to complement the 250 yellow penstemon growing along the line of the profile.

At this writing I have begun to research a second portrait which is planned for the region of my original inspiration for the *Portrait Series*, back in Central America. Working with John Hoopes, anthropology instructor at Kansas University, I have become more attuned to the diversity of native people whose ancestral homelands are located in Costa Rica and nearby regions. John forwarded my ideas and requests to Maria Antonia Bujoles, a Costa Rican anthropologist, who responded with an invitation for me to travel south to meet the Talamanque people, whose homeland lies on the Costa Rican southern border with Panama.

As I was completing the text of this book, I discovered an Associated Press article that seemingly reflects what I had earlier contemplated and which had served as inspiration for the *Nation's Portrait Series*. In that December 11, 1992, article about a Worldwatch Institute report, the reporter summarizes conclusions reached by Alan Thein Durning, a senior researcher at the Institute: "Millions of endangered plants and animals could disappear if primitive peoples are driven off their territory and assimilated into dominant cultures around the world. . . . Native North and South Americans, Australian aborigines, African Bushmen, ethnic Mongolians, Afghani nomads and forest people of the Philippines and Malaysia all possess unique knowledge that could be valuable to mankind." The report goes on to say that many tribal people have singular knowledge of plant-based medicines that may be used by modern science, and adds that indigenous groups are organizing to protect themselves and win legal control of their land, and the United Nations is considering a universal declaration of their rights to help guide states in protecting them.

The World Bank estimates that three hundred million indigenous or tribal people live in seventy countries encompassing nearly all types of climate and terrain. I believe without reservation that their concerns (for their homelands) are properly the concerns of all mankind.

THE CIRCLE

My decision fifteen years earlier to attempt the portrait of *Satanta* had eventually led me to the campus of Haskell Indian Nations University, where I spoke one day with Franda Flyingman, Don and Marilyn Bread, and other Kiowa people, some of who were direct descendants of the subject of my first earthwork. Those conversations had followed a faculty meeting which had been held earlier that morning.

It was the August morning in 1992 alluded to previously. I had felt uneasy standing near the podium listening to Leslie Evans, a Pottowatami and an art instructor at Haskell, explain our medicine wheel earthwork design to staff members who had just arrived on campus. Some but not all my discomfort was because I was next in line to speak. As I stepped to the podium an audience of 150 people seemed to be studying me. They were teachers, secretaries, administrators, cooks, football coaches, and others. With but few exceptions the faces were collectively an amalgamation of American Indian features. Together they represented the hope and heritage of many different peoples. They had come there from tribal homelands and nations located from the Gulf Coast to Canada and Alaska, from the Appalachians to the southwest plateaus.

I had planned to speak extemporaneously, but at that moment I was thinking it had been an unwise decision. Still, it seemed I needed only to tell them two things: my name, and my reason for being here. I reflected on events since I first forged an art connection to Indian people back in 1976 when the concept of etching an image onto the earth first caught fire in my imagination and materialized on the pages of my sketchbook.

Because of my dark, straight hair, brown eyes, and stocky upper build I could probably pass for being "of the blood," and I felt compelled to comment on that. As a young man my father had told my brothers and me that his ability to follow and track animals and to "read sign" was from our Indian heritage. I later learned that that relationship was too far back to be provable. Interestingly, that discovery coincided with an observed phenomenon taking place in Kansas and elsewhere throughout the southwest in the seventies, where it seemed every other white person I met had a grandmother who was "one-quarter Cherokee."

I began by telling them I am the son of a farmer and grandson of a man who brought his family four hundred miles from southern Missouri to southwestern Kansas in a covered wagon in the early 1900s, and that the land my people homesteaded was just ten miles from the Oklahoma Panhandle, which was first a northern hunting grounds for the Kiowa and Comanche. I added that in my youth I had been aware that that part of northern Oklahoma was variously known as "No Man's Land," "Indian Territory," and the "Cherokee Strip" and that my maternal grandfather ran cattle on a small ranch in "the territory" in the thirties.

While speaking, I realized that among them could be one or more descendants of people who had once lived on the very land my father was planting to wheat and which provided pasture for his cattle. The thought was fleeting, but added a bit to my discomfort. I have little recall of what I did say, but I endeavored to

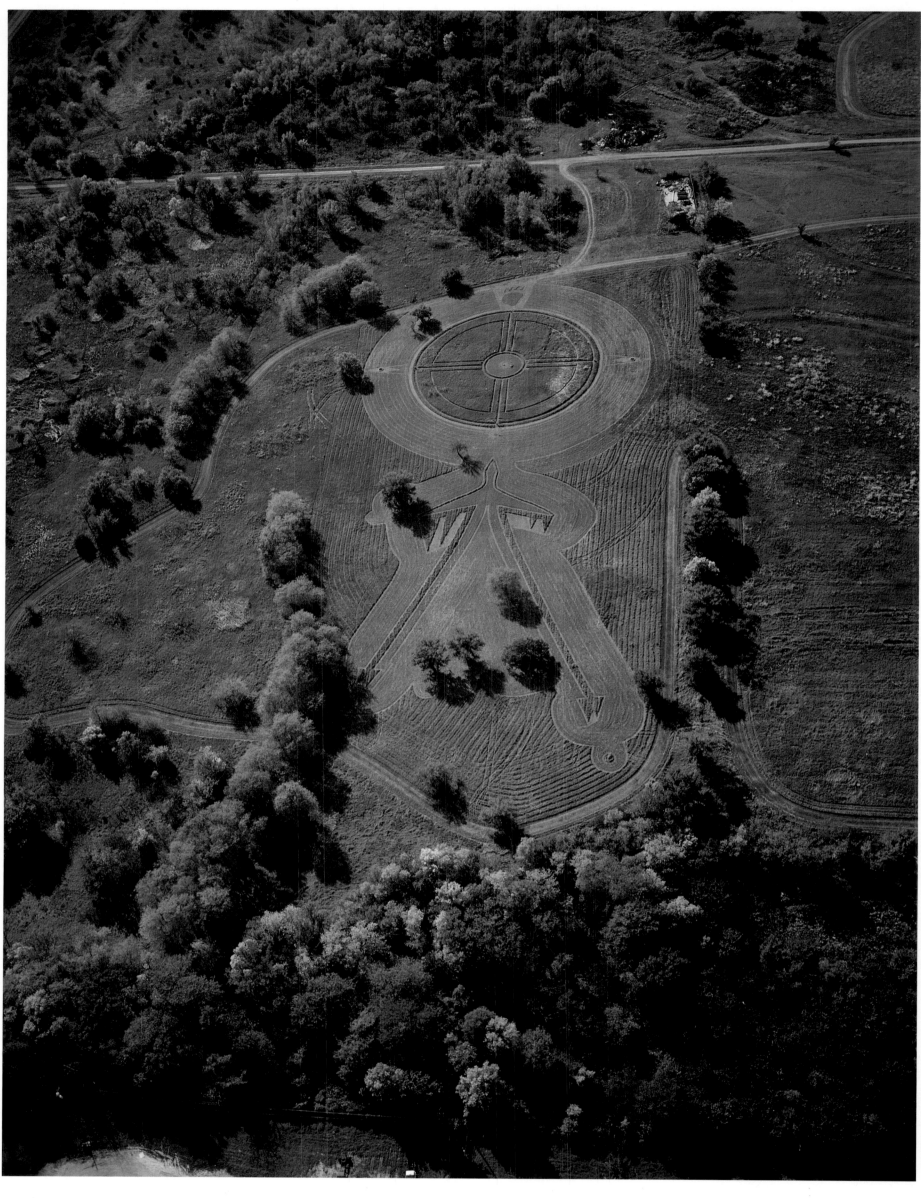

The Circle, a medicine wheel design on the campus of Haskell Indian Nations University, grew from a collaboration with Native American faculty.

Right: *The Circle* is being used for ceremonies and meditation by students and is open to all religions respectful of the site.

Below: Conceived as a contemporary artwork symbolizing a medicine wheel, the design will continue to evolve as we learn from visiting spiritual leaders.

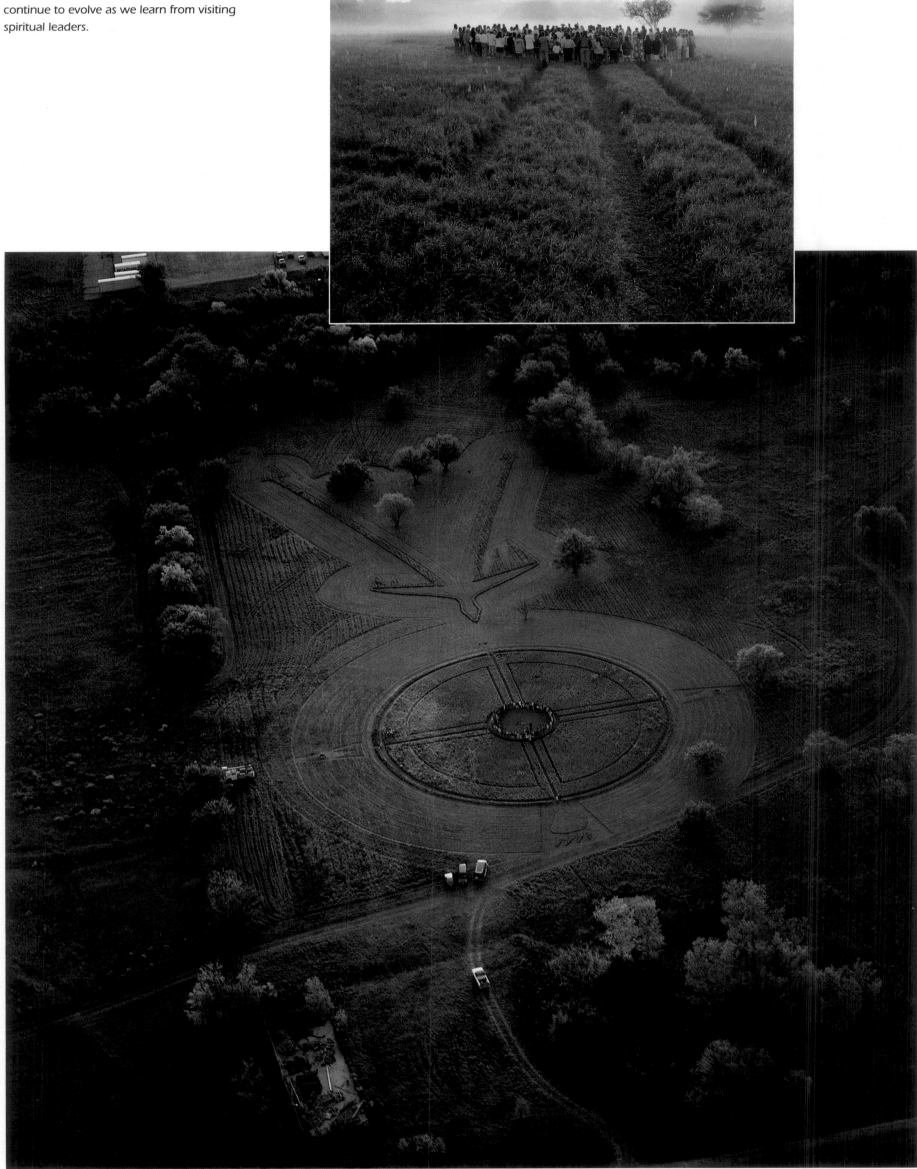

explain chronologically the series of events which began fifteen years earlier with the Satanta portrait, events that led me to help design and implement a medicine wheel earthwork set into a cultivated brome field at the back of the Haskell campus.

The idea had come from Dan Wildcat, chairman of Natural and Social Sciences at Haskell, whom I had known through a loose group of friends made up of artists, writers, teachers, and poets who make their homes in Lawrence. Many are faculty members at Haskell and at the University of Kansas. After wide-ranging discussions over a period of two years, Dan asked if I would be interested in designing a field to coincide with the then approaching Columbus quincentennial.

During that time, I had an opportunity to meet Kirkpatrick Sale, whom Dan had invited early in 1991 to be a guest lecturer on the Haskell campus. As background, Sale had authored a number of books including *Conquest of Paradise*, a study of cultures in collision in the 1500s, which also presents his view that there has been a manipulation of Columbus's reputation, especially during each of several anniversary celebrations.[7] Dan had loaned me the book to read several months prior to Sale's visit.

A few weeks after attending Sale's lecture, Dan and I walked the grounds of Haskell discussing earthwork possibilities. The meeting with Sale had further stimulated these conversations, which in turn led to Dan proposing a specific quincentennial project, a medicine wheel design. For a non-Indian to be involved with the design of a sacred symbol of Indian people appeared intrusive and impolitic to me, a questionable step, but that concern was removed when we met with Leslie Evans.

Leslie, an accomplished artist and teacher, also is engaged in important research centered on the effects of paternalism on contemporary Indian art. His research encompasses Pre-Columbian design, including medicine wheels, mounds, and petroglyphs. After that first discussion with Leslie, I began to realize what my role could be in this. With the help of his students, he would design the image and I would be involved as landscape architect and consultant to interpret the design and facilitate its implementation into the field. Leslie, in speaking about the design, describes it as "a combination of traditional symbols of aboriginal cultures indigenous to the Americas." The circle was to symbolize a medicine wheel, a contemporary art piece with overtones of a sacred space. After communication with Indian spiritual leaders in the Lawrence community as to the suitability of our plan, the decision was made to go forward. Bob Martin, president of the school and a man active in national Indian affairs, gave the final okay. We commenced the initial layout in late spring.

Native American leaders such as Thomas Banyacya, a Hopi elder and spiritual man; Leon Shenendoah, chief of the Iroquois Confederacy (mentioned earlier); Jake Swamp, chief of the Mohawk; Bill Mahoja, chief of the Kaw or Kansa tribe; Steve Cadue; and other Kansas Indian leaders came to inaugurate a "Flame Spirit Run," emanating from the circle, which was intended to carry flames to both coasts and to the Canadian and Mexican borders; runners advancing in the four directions would symbolize the Native American presence in contemporary culture. With a number of blessing ceremonies, and with student and community members using the circle for prayer and meditation, the nature

and function of the work has taken on meaning of its own.

In the ceremony on the morning of October 12, 1992, Dan Wildcat suggested that the challenge of the quincentennial year was not about the past but about our willingness to change the future. He said, "The creation of the Earthwork Medicine Wheel at Haskell Indian Junior College is offered as a Native gift to all peoples of this planet and a symbol of what we peoples of the world must now learn."

Perhaps the most personally gratifying aspect of my involvement with Haskell was the acknowledgment of the importance of my 1981 portrait of Satanta by Franda Flyingman and other Kiowa people currently working at Haskell. They informed me, after my presentation, that this leader was being inducted into the Indian Hall of Fame in Oklahoma that very weekend. It was meaningful to me that the contingent of Kiowas traveling to Oklahoma carried with them a large photograph of my portrait of Satanta to be presented to the museum at the ceremony.

Somehow on the day I first spoke at Haskell, a circle had been completed in my life as well as in my art. My journey of inquiry and quest for insight into the issues relating to these first Americans, which had started with the design of the Satanta portrait sixteen years earlier, was being manifested in new friendships on the grounds of America's oldest Indian college.

CONCLUSION

Questions are still unanswered about the reasons for ancient and more recent civilizations' creation of images viewable only from an elevated perspective; with no opportunity to see the finished work. I am taken by the proposition that many were attempts at communication—to the heavens or the gods—asking for personal and community blessings. It has been stated that "man," imitating the pattern of the parent-child relationship, has always verticalized his religious world—looking up with hope and down with fear.

If one can presume any connection in spirit to the past, I believe my earthworks are in part an effort to communicate to that same power, to somehow connect me with this ancient world. All artists today are products of an era without precedence in noise, hype, and art as an article of commerce. Certainly earth artists of the past did not have to deal with the issue of commercialization, the media, and the ego piqued by the occasional art critic. Our motives can never really be compared.

Recently my wife and I, along with our son, moved from the noise and congestion of the city, out to the country a few miles from Lawrence. We have taken up residence with a covey of thirteen quail, a number of rabbits, and a particularly talented mocking bird. Hours after the dust settles from all of our human activity we are often serenaded by the chorus of a family of coyotes. We recently planted a circle of Pawnee blue Indian corn, a gift from a friend. The condition of the gift was that when the harvest comes in we are to make bread with a third of the crop, keep a third for replanting and share the final third with friends. We were also directed not to profit from the corn, and to share the crop with the wild things that find their way to it. It sounded so simple. I had almost forgotten the language of the country.

ACKNOWLEDGMENTS

To my parents, Dewayne and Dolores Herd
My wife and companion, Janis
My spiritual twin and brother, Stewart
My friends at Haskell Indian Nations University
My friends at the Land Institute

And to the farmers: Lester Rogers, Louie Byers, Jack King, Harlan Courtney, Lawrence Lundstedt, and the Sam Neis, Jr., family—in memory of Elizabeth; the phtographers: Peter B. Kaplan, Daniel Dancer, Georg Gerster, and Jon Blumb; for help in writing and editing this book, my thanks to Janis, Fred McCraw, Philip Collins, and Beverly Fazio.

PHOTOGRAPH CREDITS

NOTES

1. Quoted in Barbaralee Diamonstein. *Inside New York's Art World*. New York: Rizzoli, 1979, p. 85.
2. Ralph Rugoff. *Utne Reader*, No. 54, November/December 1992, p. 99.
3. Lewis Hyde, review of *Altars of Unhewn Stone*, *The New York Times Book Review*, September 27, 1987.
4. Hugh Honour and John Fleming. *The Visual Arts: A History*. 3rd ed. New York: Abrams, 1991, p. 624.
5. Quoted in Ellen H. Johnson, ed. *American Artists on Art*. New York: Harper & Row, 1980, p. 33.
6. Wes Jackson. *Altars of Unhewn Stone*. San Francisco: Northpoint Press, 1987, p. 9.
7. Kirkpatrick Sale. *Conquest of Paradise*. New York: Penguin, 1990.